THE MASTERS OF MODERN ART

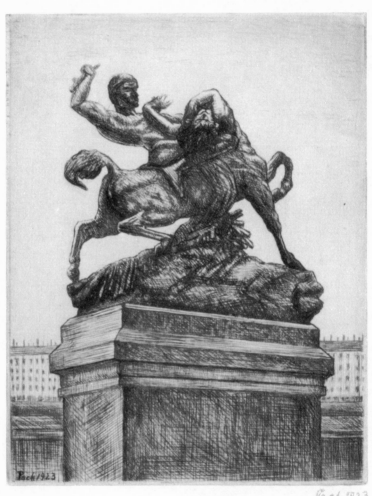

THE MASTERS OF MODERN ART

BY

WALTER PACH

Essay Index Reprint Series

 BOOKS FOR LIBRARIES PRESS
FREEPORT, NEW YORK

Library of Congress Cataloging in Publication Data

Pach, Walter, 1883-1958.
 The masters of modern art.

 (Essay index reprint series)
 Bibliography: p.
 1. Art, Modern--19th century. 2. Art, Modern--
20th century. I. Title.
N6447.P3 1972 709'.04 72-5633
ISBN 0-8369-7295-3

TO MY WIFE

The present book offers in revised and considerably expanded form a series of articles which appeared in *The Freeman* (New York) during 1923.

CONTENTS

ILLUSTRATIONS

Illustrations

Illustrations

THE MASTERS OF MODERN ART

THE MASTERS OF MODERN ART

THE MODERN PERIOD

Two epoch-making events, the French Revolution and the World War, mark the opening and the close of a period of history which we of to-day call the modern period. It grows out of the past after a fierce struggle but without a break in the continuity of human effort, and it leads into the after-time, again with a terrific upheaval, and again without interrupting the logic of our evolution. And thus it is with modern art, which is simply the ensemble of the painting and sculpture that tell us of the genius of the period (whose expression through architecture and the applied arts is of relatively slight importance): the line of descent from the past turns sharply with the Revolution but it does not break. The external control of the kings is gone, and with it the orderliness and decorum of aristocratic periods. But if there is turbulence after a regicide painter has initiated the period, there is still control: the inner control of human genius, going on to a succession of triumphs which make of modern art something which will stand with the greatest achievement of the modern period and— we think (for only the future can say)—one which can take its place beside the great achievement of the past.

To-day as we stand before a new period, we see how immense was the accomplishment of the one which is ending. We see the limitless power that surged up

with the French Revolution and vented itself in the renewal of classic line, with Ingres, and of classic color with Delacroix. ⟨The power of the time, impatient of the idealistic symbols of the past, creates its own symbols, as the fierce pride of the Realists bends the glance of men from imagined divinities and distantly remembered history to the actual men and women and the material objects of Courbet, to the living crowds and characters of Daumier. The new idea, as we see it with these artists, is as vast in its effects as was the contribution of the great Dutch school after that of the Italian schools. The energy of the time, far from relaxing after such efforts, goes on to enrich its means, calling to its aid arts newly recovered from the past or from distant races; it calls on science to give it control over the magic of light and over aspects of nature which are represented so perfectly that they seem only to have been hinted at in the earlier centuries. And with the enormous range then possessed by modern art, the need for a synthesis of all the qualities suddenly appears—and is triumphantly met. As a result, men press on to a new analysis, a new statement of the means and purposes of art, and the period, at the outbreak of the Great War which doubtless heralds another era, still radiated a vitality which seems in no way inferior to that of the great epochs of the past.

If the foregoing estimate of modern art is still that of a minority, it is so because our accomplishment in the realm of material things is of so striking a nature as to claim at present more than its due share of attention; and also because the art of our period has to be extricated from a mass of insignificant or counterfeit production such as no time in the past had to contend with. That the future will make this elimination is

beyond doubt, even as artists and the close students of modern art among laymen are making it to-day. The purpose of the present book is to bring before a wider public the result of their study. If we follow from one to another the masters of modern art, the great numbers of lesser but still valuable talents naturally take the places due them. The period is so rich that a very big volume would be required if we proposed even briefly to consider the men and women entitled to rank as artists but unable to show that creative power which gives a new direction to art and so characterizes the *masters*. In the United States, for example, even such admirable men as Winslow Homer, Albert P. Ryder, and Thomas Eakins can scarcely be regarded as having contributed essentially to the evolution which I shall endeavor to trace here. And in giving to this book its title, I am aware that there can be nothing definitive in any attempt to follow the course of mastery in a period to which we still belong. The consideration of the modern development which I present here is sure to be revised by time. Yet I can offer it with more confidence than that justified by a merely personal opinion for, having known many of the living artists I mention, as well as a number of the great men of the preceding generation, I feel that the opinions here expressed at least approximate an average of their ideas as to the men who have best carried on the heritage from the past. Our problem in appreciating the greatness of modern art lies in following the unbroken line that leads from the older classics to those of the present day.

Not a single American museum as yet affords sufficient material for such a study. The fact is regrettable; for the public, eager to understand the genuine

works of the present time, finds nowhere a consecutive series of those works which would show the achievement of modern artists, and the whence and whither of the evolution of the modern period. We are likely to think that there never was such a time before; but if we listen attentively to the echoes of the past (such as are gathered up by Count Gobineau, for example, in his book, "The Renaissance"), we see that the disputes of our epoch very largely repeat those of the Quattrocento, that marvellous century which is probably nearest in character to our own. Or let us take a phrase from Petrarch (as quoted by Tancred Borenius in his notes on Crowe and Cavalcaselle), and through it consider the general appreciation of Giotto at a time less than fifty years after his death. In his will, Petrarch wrote as follows, "I bequeath my picture of the Virgin by the noble painter Giotto, whose beauty, unintelligible to the ignorant, is a marvel to the masters of the art. . . ." Change the name of the Florentine artist to that of a modern master and the words "unintelligible to the ignorant etc." might as well have been written by an enlightened collector of our day as by the old poet standing at the threshold of the Renaissance and its rapidly changing ideas. The latter part of the fourteenth century had been a period of relative calm in art, corresponding to the aristocratic certitude of the painting before the French Revolution; the Middle Ages had given the world a final and supreme expression in Giotto, and after him there is nearly a century without any important movement in art. Then—and with a scientific turn exactly parallel with the development witnessed throughout the earlier part of our epoch—the fifteenth century gets under way and, with increasing impetus, investigates perspective,

modelling, atmosphere, chiaroscuro and anatomy. The distance covered between the work of the late Giottesque painters and the painting of Raphael and Titian is nearly as great (or greater, who shall say?) as that between the end of the eighteenth century and the present day; and if there is any ground for the charge of irreverence for predecessors sometimes brought against the moderns, what shall we say of the Renaissance artists, who thought so little of the older men as to cover over their works with whitewash, so as to have more walls to paint on?

The great difference between the modern period and the past lies in the realm of judgment and authority. At the present time there is no parallel for the wisdom with which the fifteenth century, for example, faced its new problems, for power was then in the hands of competent men, and however swiftly the changes in art came about, the temporal or spiritual lords who gave employment to the artists were equal to the task of selecting the great men to do their work, the minor artists being assigned the less important tasks, or remaining craftsmen (all artists began as craftsmen). When the Emperor Charles V made his famous remark that he could create nobles but that God alone could create a Titian, he was not so much giving the measure of an artist's greatness as leaving to posterity a token of the kind of judgment that Renaissance princes possessed; and as one looks over their portraits and the decorations of their palaces, one sees how general such appreciation was among the rulers of that time.

After the French Revolution, the great change began at once. There was no longer a Pope Julius II to call for the decoration of a Sistine Chapel, no longer a Charles V to stoop and pick up the brush of Titian,

a Philip IV to pass his days watching Velasquez at work, nor a Burgomaster Six to delight in the society of Rembrandt. No one knows to-day where authority resides in matters of contemporary art, and the past is continually being fought over. The Revolution took the Louvre away from the Kings and gave it to the people as a public museum, and the French idea was followed all over Europe with the creation of the great public galleries, a new and powerful influence in the modern period. Where, in the past, works of art, especially those of distant places and times, had been difficult of access, the whole art of the world was spread out for everyone, and each year saw the treasure grow in quantity and diversity. Instead of the relatively simple standards of the earlier time, an immense amount of ancient material, superficially different from current production, lent the weight of its prestige to a fabulous "golden age" in the past and brought about a false taste for things resembling those consecrated by the museum. To-day we see that nothing so much resembles a fine ancient work as a fine modern one, however different in outer aspect; and that no work is farther from the classic than that which copies merely its externals. But we have come to this knowledge slowly, through an ever deepening knowledge of the museum; and we find it difficult to place ourselves in the mental attitude of the people of a hundred or more years ago who first saw the shift in standard—from arts which were familiar and natural for everyone to arts which had previously been known to only a few. This change, for which the multitude was not prepared, created a distinction between museum-art, a thing to be visited occasionally, in a stately and rather cheerless place, and what is wrongly

called popular art—the trivial stuff that unthinking people can understand and live with.

The genuinely popular arts of the past—the old handicrafts such as iron-working, pottery, and furniture-making—began to decline shortly after the beginning of the modern period, when machinery assumed its enormous development and rendered the competition of hand-made products commercially impossible. The disinherited craftsmen, still needing an outlet for their skill, but lacking the spiritual power which alone gives value to the fine arts, turned to producing paintings, illustrations and statues for the crowd. It has been estimated that the annual output of such things in Paris alone is more than a hundred thousand works, a figure not to be explained by the city's needs—or the whole world's—but by the need of the artists to produce. Here again is a condition for which there was no parallel in the past; and, with the loss of leadership, it was the democratic factor of quantity, not the aristocratic factor of quality, that decided the making of sales and thus the awarding of prizes and public commissions. A generation ago, popular favor went to such men as Sir Frederick Leighton, Bouguereau and Lenbach. Are the "crack" painters of a later fashion, Sorolla, Besnard, Zorn and Sargent, for example, any happier as a choice? Evidently abler than other members of their school, perhaps sincere according to their lights, and usually above the level of the abject realism and sentimentality of their Salons and Academies, they are as far from the genuine art of their time, as far from the great tradition of all time, as were their predecessors.

The continual increase of the rank and file of artists has entailed a keener struggle for a living and a fur-

ther lowering of standards—which have been sinking pretty steadily for the last hundred years. The modern world would make a pitiful showing indeed if its artistic achievement were really represented by the artists who are in control of most of the art-schools and exhibitions in all countries, and whose work hangs in too many museums. Fortunately, the "official" bodies, by the very excess of their zeal in boycotting the masters of their time, have come to be distrusted. Is it surprising, indeed, when a rancorous dwarf like Meissonier, using as a pretext Courbet's connexion with the taking down of the Vendôme column, could say, "He must be excluded from the exhibitions, he must be considered by us as one dead," and so rid the Salon of the artist who was probably the greatest painter then at work? An even more striking proof of the perversion of judgment brought about by modern conditions, is to be found in the fact that Cézanne, the artist most highly esteemed by the generation that followed him, was never able to get one picture, of all that he sent so regularly to the Salon, accepted by its jury. His single chance to exhibit there came to him through the "charity-vote" of a friend who had the right to pass a work without the consent of the rest of the jury.

I have said more than enough about the false art of the modern period. As a rule the mere mention of such a thing is an offence against good taste; but when even a negative element in a period is as conspicuous as the academic and the commercial aspects of the art of our time, it can not be passed over in a summary of conditions, however certain one feels that the future will regard it as a misdirection of energy. That could never be said about the work of the minor artists of the

past. These men, so often dignified and lovable personalities, were not the enemies but the coadjutors of the masters of their time, even as the great patrons of the old days were in their way. The old princes and priests whose hereditary culture led them to know art—and know the artists—have but few successors among present-day collectors, who often come to their interest in art late in a lifetime occupied with very different things and are thus but rarely able to form valid judgments on a subject which exacts close and intimate acquaintance. Perhaps the real reason for the misunderstanding of art in the modern epoch is the individualism which prevents men from working in common. This probably accounts for our failure to produce architecture, the art which demands the collaboration of many men animated by a single purpose. But the closing of the outlet for energy which architecture and the crafts afforded to the past, caused the art-impulse of the modern world to be concentrated in painting and sculpture and gave to the latter their peculiar intensity.

As we study the men who have expressed this art-impulse, we find that it is again the museum to which we must turn for an explanation of their course. From the beginning of the period, when Ingres went to Italy and discovered the primitives, when—a little later—Delacroix went to Morocco and discovered the Orient, we see the tendency of the modern world to extend its horizon and set its art upon a wider base than that upon which the perfect but narrow art of the eighteenth century had rested. Greek art was studied anew and from such examples (the Elgin and the Æginetan marbles, for instance) as had not been known since before the Christian era. Then came an interest

in Egyptian and Assyrian art, which like the Gothic and, in the second half of the nineteenth century, the art of the Far East, came to be looked on as supremely significant and not as curiosities outside the great tradition. In the last decades we have gone even farther afield: Gauguin brought us an influence from the art of the South Sea peoples, and the later men have extended their investigation to the principles of Byzantine, Hindu, Negro and Mexican art. Thus, from Ingres, discovering the early Italians in his youth and, at eighty-seven, copying Giotto "so as to learn," as he said; through Barye with his great debt to the archaic Greeks, and Delacroix with his color so strongly affected by his contact with the world of Islam; through Courbet and Manet, learning from the Spanish and Dutch realists—who had been outside of the central tradition of European painting; through the Impressionists with their love of the unshadowed color and the clear design of Japanese prints; through all these artists and down to the men of our day whom I have mentioned, the modern period has been one of new influences. They have marked our art indelibly: with each new decade we have found ourselves farther from the local or, at most, European outlook of the artists who lived before the nineteenth century. This does not mean that the gods of the earlier schools have in any way been relegated to a lower position in the opinion of the modern world. I believe, on the contrary, that our new understanding of the exotic arts has given us a new and deeper appreciation of the supremacy of the classics of Europe.

When we find these classics themselves and the less familiar schools made known by the modern museum changing our vision, as they did a dozen times through-

out the period, we are still, of course, strictly within the field of art. Thus, if an archaic Apollo was recognized as an immeasurably healthier and purer expression than the "perfect" Apollo Belvedere, and artists, in trying to recapture the qualities of the earlier work, moved away from the extreme naturalism of the Greco-Roman decadence, they were enriching themselves from their own resources. But they went beyond these into the domain of science. It was but natural, therefore, that laymen should apply to art the standard of scientific logic which achieved such wonderful results in the world of the inventor, for example. Yet for the artists, the true ones, their new acquisitions from science were only tools, to be used for the traditional æsthetic purposes which all such discoveries in the past had served. To the great public of the last half century or so, scientifically accurate representation seemed in itself the aim of art, and so the breach between artist and public widened still further. The realists, observing certain half-forgotten laws of optics, gave a rendering of solidity and actuality that seemed at first monstrously vulgar, and later, when people grew accustomed to it, made the work of the preceding generation appear somewhat artificial. Following hard on the heels of Daumier and Courbet, the young Manet studying the masterpiece of the great realist at the Salon, said of the "Burial at Ornans," "It is too black." Then begins that observation of light which culminated in the reduction of the study to formulæ as precise as those of anatomy or perspective. These in turn were abandoned by the designers of the Post-Impressionist group; and so each time that we approach the method of the scientist— the employment of principles which are invariable for

all men—the period shows its strength by rejecting a type of absolute which is contrary to that of the artist.

For when we transpose to the realm of thought the objects with which the physical sciences deal, we utterly transform their properties. The final lesson of the museums has been that the realm of art is the mind, and that external criteria of judgment, measurements by size, weight, light, etc., are inapplicable to the work of art or to any phase of it. Moving towards the grandeur of the symbols to which the Byzantine mosaicists, for example, gave form and color, Christian art was not retrogressing when it abandoned even the supreme perfections attained by the pagan world in its realistic art. The Byzantines were giving the appropriate expression of their ideas, even as the Greeks had done when they abandoned the hieratic formalism of Egypt to produce an art based on their new delight in the meaning that they found in nature.

The periods of decadence are those in which man is too weak to perceive new aspects of the world, when he can only attempt to repeat the expressions of the past—a hopeless task, for the ever-changing world never shows the same features twice. The strength of the modern period is precisely in its power of renewal, in its bringing forth the succession of masters whom we shall attempt to follow in these pages—the men who have given us the greatest record of an era of amazing health and fecundity.

FROM THE REVOLUTION TO RENOIR

ALTHOUGH the art of the first three-quarters of the nineteenth century gave rise to discussions which exceeded in bitterness those of our own day, time has pretty definitely decided the questions of that period, and our present concern with its masters is for the aid they can give us in tracing the continuation of their line through the maze of tendencies which have since arisen. \The first step in the search is to observe that modern art is, if not exclusively French, at least an art having Paris as its hearth and focus. The great men outside of France at the beginning of the modern period, Goya, Blake, Constable and Turner, all formed their art in the eighteenth century, which is to say, in the preceding epoch. We may therefore regard them as splendid figures in the transition between these two centuries rather than as distinctly modern artists. When, in the time under consideration, we reach foreigners of the first rank, like Jongkind, van Gogh and Picasso, we find them coming to France and carrying on the work of the French school. The fact is of the greatest significance in explaining the length of time that French art has existed as a continuous and vital thing. Where Italy, Spain and Holland have brought forth schools of the utmost importance, their history has been terminated in each case by a decline without a renewal. France alone goes on through the centuries, always herself and yet always able to accept from others the aid which will enable her to issue from the

13

decadence of one idea with a new one already in full course of development.

It is this process which we see throughout the modern period and which best explains its genius. One must not ask, as in slow and tradition-governed epochs, how much of a predecessor's qualities a given artist carries along; the need of the time was to find new expressions for the swiftly changing life of the world, and the masters were those who offered new values to a period which was revaluing everything. In such a time, the character of the French mind, so tenacious of its classical heritage and yet so quick to feel the stir of contemporary life, could and did serve the world as no other could.

The master who leads us to the modern period, the one who does not merely influence it, like the great Spaniard and the great Englishmen whom I have mentioned, but who dictates its course in its first years, is David, the incarnation in art of the French Revolution. Beginning with the elegance and wisdom of the lovely *Dix-huitième,* he stands like the guillotine (it was Victor Hugo's word in regard to him) that brings the preceding era to its close and clears the way for the next one. As our purpose is to read the character of the present day through that of the past, let us observe that the great artist of the Revolution works on grand and impersonal principles derived from his study of the antique, and does so in almost the way that his devout admirers, the Cubists of the war-period a hundred years later, have built their art on principles so severe as to lead to an abstraction from which nature as seen is completely banished. Such peaks are reached by men at moments of storm and stress, when they can carry logic to the conclusion reached in the grim

lines of David's "Oath of the Horatii" or in the actions of a Robespierre; but it is bleak to live upon such heights, and so men pass beyond them.

David himself passed beyond them, especially in his portraits. Not to single out even that most adorable one among them, the "Charlotte du Val d'Ogues" in the Metropolitan Museum of New York, almost any of his images of men and women is charged with so direct an interest in life that we forget all the neo-classical paraphernalia of the artist's historical painting. In the severe order of his canvases, in their aspect of reason, of logic, we see the mind of the Revolution and of the republics of antiquity whose support it invoked. The great blocks of form which build up the design of the "Marat" in the Brussels Museum have the bareness and impressiveness of Roman architecture, and it is as the man capable of rising to such grandeur of conception that David must be remembered. He has been traduced by the school which claims descent from him and which is sufficiently characterized by a detail of its procedure still recalled by some of the older men in Paris. That learned and excellent painter Paul Sérusier told me that it was the practice in the so-called Davidian studios he knew in his youth, to save the scrapings of the palette, the colorless mud left after the day's work, so as to use it for the shadows in the morrow's painting. Granting that color was not David's means of expression, one knows that a travesty of one of the beautiful attributes of painting as dismal as the practice mentioned could not have come from the master, but from his unworthy followers.

Their bad tendencies were doubtless what provoked the revolt of David's greatest pupil. In Ingres we find

the genius of France for reaping a new harvest when the fruits of a former one are exhausted. He goes to Italy, discovers the Primitives (whose name still had its derisive meaning), and himself incurs the charge of being a "Gothic." Thus, beginning with the first master who is distinctly of the modern period, we have an example of the need among its artists to seek in the past for new æsthetic elements from which to form their art, and also, in the—to us—astounding attacks which the early masterpieces of Ingres drew forth, an example of the misunderstanding by the public and the critics of each new talent of capital importance that appeared. To this rule there is no exception, and in Ingres's case we find him writing, very late in life, that he is out of harmony with his century and wants to withdraw from its whole activity. His love of the masterpieces which surrounded him in Italy is not enough to explain his prolonged sojourns in that country: we know that Italy was his refuge from the opposition he found in Paris.

The resentment of his earlier years against those who condemned his art in the name of the schools just before his own was transferred, later on, to the Romanticists, not seeing that as his use of line brought into the world an art akin to that of his beloved Raphael and the Greeks, the color of Delacroix reverted to a form of expression which, as in the time of Titian or of Rubens, was to yield results no less necessary for the completeness of that supreme achievement which European painting is. Above all, Ingres did not see that the new men, in giving freer and freer rein to the rising strength of the period after the Revolution were only following the course which he himself had indicated when he rejected the academic caricature of

David's genius. And it is not from his poor imitators of the École des Beaux-Arts that his own influence is to be judged; the true line of descent from Ingres is to be followed with the men who penetrated to the real meaning of his work—with the creators, like Degas and Renoir.

It is true that Ingres said that the study of the young artist should be to raise himself to the feet of Raphael and to embrace them. It is true that in works like "la Vierge à l'Hostie," the "Jupiter and Thetis" and the "Apotheosis of Homer" where he came his nearest to failure, it was through an abnegation of his own genius which led him to try to repeat the achievement of his master. But let us turn to any of his great works, the "Grande Odalisque," the "Vénus Anadyomène," the "Madame Moitessier" or the portrait which seems to many of us the most beautiful of all, the "Madame de Senonnes," at Nantes; consider the drawings, particularly the studies—there is no longer a trace of the follower of Raphael, it is a completely detached personality we have before us, and the discipline to which it had been subjected only concentrated the effort of the artist on those problems which he cared for.

To study the art of Ingres, one is forced, more than with most other painters, to meet him on his own ground. Setting aside any comparison with Raphael and the Greeks on one hand, and the still more futile contrast with Delacroix on the other, one sees the perfect mastery of line and plane and their ceaselessly varied combinations. And one sees above all that every nuance of line, every movement, bend or halt of the planes, came in response to the working of the artist's mind. Few pictures reveal more of deliberate planning than Ingres's, but the whole passion of the

man's southern nature went into the execution of his plan. Convinced of the loftiness of his ideal, of the supreme greatness of the arts which had been his inspiration, he laid out his course and held to it with unswerving probity—to use his own word. This singleness of aim, supported by a prodigious strength of will, frequently carries his work to the level which we call perfection, and so makes it one of the symbols of human genius. We have never the right to demand that perfection be added to, and Delacroix's terrible dictum as to his rival's work—"The complete expression of an incomplete intelligence" can mislead while it illuminates. Does anyone think that Ingres would have added to his perfection had he permitted himself a broader range? Whoever has reached even a tentative understanding of Ingres's art, has felt the appropriateness of his color, and realized that no change in it could be for the better. So too his manner of painting is mastery itself when applied to the order of ideas he had to express.

But we must face that fact that there was narrowness in the ideas themselves. One writer has seen in Ingres a sort of double personality—the fiery, intense nature of the southerner, and "Monsieur Ingres" as the French call him to this day—Monsieur Ingres in awe of the purity of the masters and keeping an iron restraint on the hand of the painter. Again and again Ingres the painter shakes off the critic, and before the freshness of some girl-model, finds lines whose spontaneity can not be explained by the principles of design. In the portrait of Madame de Senonnes there is color which could only have come in a moment when he abandoned himself to the deep sources of his nature, which his intellect and will were powerless to call into

play. He distrusts such contact with external nature
as was to become the watchword of the men of Barbi-
zon; he is jealous of concessions to the impulses within
us too deep for reason—which were to furnish material
for arts greater than that of Barbizon. And yet his
own art has so much of these impulses playing through
it, that only when following his classic models too
closely did he fail to find the subtle divergence from the
vase-form that makes his drawing of a head or muscle
lovely, or the subtle varyings of the geometry of his
design, that save it from coldness and make it live. If
we cannot regret the narrowness of Ingres' range, at
least there are times when we wish that he had given
freer play to the powers he had. The Greek calm, pro-
ceeding from the balance of all ideas in full utterance,
does not breathe from the ensemble of his work. But
if in the very perfection of Ingres there is a sense of
ideas repressed, there is also the grandeur of our mod-
ern period, when art is attained only after struggle,
such as the world of antiquity seems not to have known.
The modernity of Ingres is best attested by the paint-
ers who follow him throughout the century: did he
not belong so fully to his time, we should scarcely find
men as different from one another as Courbet and
Manet, Degas and Renoir, Derain and Picasso seek-
ing his guidance. Even Cézanne, pushing his re-
search into regions where the "divine line" of Ingres
has no place, must render homage to him with an ejac-
ulation of droll regret: *"Ce Dominique est bougre-
ment fort."* To-day, when the younger generation,
again turning to severe realism and to classic measure,
has renewed its admiration for Ingres, we see the
strength acknowledged by Cézanne as something that
could assert itself once more, after nearly a century

during which the Romanticism of Delacroix was the triumphant tendency.

It is still this mood of adventure, carried to one of its farthest limits of expression, which Delacroix symbolizes to us to-day; and if this is so, almost exactly a hundred years after the "Dante and Virgil" announced his advent to Europe, how much more electrical must the effect of that masterpiece have been upon his contemporaries! Goya had indeed done work of a similar expressiveness, but at that time he was known by few people outside of Spain. Géricault's "Raft of the Méduse," which had been exhibited a few years before, certainly announced the great spirit of drama of the early nineteenth century, but as its subject gave it both a journalistic and a political interest, the tendency of art was not really defined for the world until Delacroix exhibited his great canvas. Moreover in the "Dante and Virgil" there is a first fruit of the younger man's genius for color, which Géricault would probably never have equalled, even had his death at the age of thirty-three not cut short his career. The color of Delacroix, the thing of flame which leaps under the sun of the Orient he discovers, the rich, sonorous thing which he can use with the purity of his beloved Mozart, or which he can make resonant with the majesty of Beethoven—who is probably the musician most like him—this color of Delacroix's which the future may yet call equal or even superior to any produced by Venice, was a necessary means for the voicing of that Romanticism through which the modern period asserted its existence as distinct from the past, more strongly than David or Ingres had done.

Indeed, for us to-day it is very difficult to see in In-

gres anything but the classical strain—the qualities in which all men are sharers. Delacroix seems nearer to us because he yields so much more freely to the feelings which belong to the individual—and in the modern period it was the Romantic, inner world of the individual that enjoyed always increasing interest. But to understand the immense influence which Delacroix has continued to exercise, we must see him from the standpoint of what is impersonal in his art. The chapel which he decorated at St. Sulpice in Paris has taught the great moderns for the last sixty years almost as Masaccio's chapel in Florence taught the men of the Renaissance; and in neither case did the later artists come to the master for so vague a reason as his personal greatness, but because of the definite, even technical instruction to be obtained from his works. Though we see a heritage from Delacroix's impassioned spirit in the vibrant, swaying and yet controlled rhythm of a Renoir, of a Seurat, or of a Matisse picture, the intellectual contribution of the great Romanticist—his bringing back of the almost forgotten laws of color, made the after world his debtor even more than his revealing of the heroic freedom of his time.

The two phases of his mastery are closely related. He knows so well the vehemence of his expression that throughout his life he never ceases to seek the means of strengthening the technical structure with which his expression is fused. His paintings alone would tell us of this, but in addition we have his Journal, with its innumerable entries as to the nature of design and color during the forty years that it covers. And in his splendid essays on the theory of art and on the masters we follow him in his insatiable study, and understand how his mind could go past the

works of Poussin, of Veronese and of Rubens to a still more classic source. For, when we turn to Delacroix after a contemplation of the frescoes of Pompeii, he appears as the artist who gave to the modern world that classic perfection of color which, in Greece, must have rivalled the beauty of form. Coming near the end of antiquity as it does, and doubtless the work of minor men, Pompeiian painting is still so marvellous that we can have confidence that it gives us a true insight into the great pictorial schools of its time and the time before it. Remarkably enough, it not only offers the best confirmation of the validity of Delacroix's color sense, but its means—the breaking up of the tone into its component hues—is the very one that Delacroix was developing, for himself and his successors, the Impressionists, and Neo-Impressionists.

The confidence in the master that we find among the later French artists is derived from a recognition—due to their classical inheritance—that it is Delacroix who brings to them the most important tradition of European painting. The purity and intensity with which the tradition is embodied in his own work is only to be appreciated from the actual seeing of a picture such as the one reproduced in this book. The beauty of this painting—a meeting-place of instinct and experience—could come only at the end of a career filled by the incredible activity of a Delacroix. It is symbolic of the whole genius of France—the revolutionary genius that breaks with outworn formulas, and the conservative, constructive genius that transmits the essentials of our earlier achievement to those men of the modern world who are worthy to carry on the work.

It is because of Delacroix's color that he was looked

on as the standard-bearer of his movement. Yet with him we must remember another master whose genius one may scarcely consider inferior to his own: Barye, loving fierce movement as much as the Romantic painter and producing those sculptured Titans of the animal and human world wherein his knowledge of the archaic Greeks underlay the structure and opened to it certain possibilities of controlling violence through logic which were unknown even to the greatest masters of the Renaissance, who based their art on that of the Romans and the Greeks of the decadence. With all that has been written of Barye's equal interest in animal and human subjects, I do not think it has been noted that the fact is one of the marks of his position as a Romanticist, for the artist who colors all nature with his mood as the Romanticist does, will make any object his symbol. A glance at his tranquil figures convinces one that the force which thrills us in his whole work comes from the mind of the artist and not from nature of his subjects.

The Barye which, because of its size and placing, is the one that gives us our truest estimate of the monumental character of his art is, indeed, a portrayal of struggle. But the subject of the "Theseus Slaying the Centaur" might have been chosen by a lesser artist, whereas no one but Barye could have conceived the mighty silhouette that towers over the Seine in that secluded nook on the Ile St. Louis where Paris (in collaboration with American admirers of the master) has erected the greatest sculpture of modern times. No less a man than Barye could have found for the Romantic subject that Classical structure, so firmly determining the great lines, and binding the innumerable details into such unity that the slightest change

would entail the modifying of the whole work. Consider the three Graces on the candelabra made by Barye for the Duc d'Orléans and ask yourself whether it is not to Michael Angelo alone that one can turn, in the last five hundred years, to find the human figure treated with such nobility. I have spoken of the "Theseus and the Centaur"; stand before that other Theseus who fights the Minotaur and try to think of a modern sculptor whom the Greeks of Ægina or the others before the time of Phidias could look on as so worthy an inheritor. Indeed the beauty of proportion which distinguishes the "Theseus Slaying the Minotaur" is one of the best examples of what the introspection of the Romantic School did in bringing to light phases of art neglected for long periods but never lost from the depths of the human mind.

And yet this work, in which Barye stands nearest to the Greeks, does not reveal a trace of the *epigoner* —the man attempting to express in one epoch the ideals of another. The ideal is of the Nineteenth Century and Barye had the wisdom to draw from the immense heritage of the past only those properties of its masters into which his particular genius could breathe the breath of life. No man can use everything that the Museum has to offer, and it is always to the problem of form that Barye addresses himself,—in his occasional (and impressive) painting as much as in his sculpture. His works supply one of our latter-day definitions of the quality. Apparently separated by centuries from Ingres's form with its suavity, its subtlety, its perfections like those of Greek vases, it appears in Barye's work with the turbulence of the Romantic movement. But it never fails to find its equilibrium. Where the planes are piled up most violently,

as in the great work on the Ile St. Louis, one finds that the sculptor has found the means of balancing one direction by another; where the muscles and fur of his animals present the most intricate surfaces one sees that they are never allowed to interfere with the underlying design. The details of his sculpture in their planes, as the masses which these planes build into a great architecture, are to be judged according to the law of art, and Barye, neither a copyist of nature nor of the classics, brings a new harmony out of his tumult.

The rôle of Corot in the evolution of the nineteenth century is evidently a different one. An admirer of the great Romantics, his serene spirit kept him from having a part in their combat, and if he shared their reprobation, it was because the self-styled defenders of tradition lumped together all work having an appearance of novelty. In reality his art descends from classic sources as easily as does that of Ingres. We search it in vain for traces of the self-questioning of the Romanticists and their struggle to give a freer movement to the mind of the artist. What deceived the academic school as to Corot (if indeed genius alone was not sufficient to arouse its antagonism) was the fact that with his classical design he combined a nineteenth century love of nature and a close observation of her appearances.

The advance made by the painters of Barbizon was not along æsthetic lines. What they brought with them from Paris in the way of influence from the Louvre gives a classical foundation to their art, but their general tendency was more toward nature than toward the Museum. Corot alone amongst them never lost sight of the masters who first guided him.

From his earliest work to the painting of his old age, he goes on in tranquil confidence of their support. His trees sway with the breath of morning, but their lines are under the control of a mind informed with the grace of Tuscan and Umbrian draughtsmen. His skies have the gentle clearness which makes them a perfect tribute to the beauty of French landscape, but his study of nature never permits him, even for a day, to forget the lesson of Claude Lorrain: the clouds move according to the needs of the design quite as much as to the direction of the wind, and the ethereal sky bends to the fairyland at the horizon in subtle planes that complement those of the earth. Poussin's anatomizing of the ground and his organizing of the forms thus obtained are to be found also as part of the sure base of this delicate art, whose firmness of structure has made it endure in our interest even more than the lyrical strain of the Theocritus of painting, as Corot has so charmingly been called.

While his landscape was what first endeared him to the public, one more often finds in his figure-pieces the purity of form which has maintained and increased his prestige among the artists. Before a work like "La Femme à la Perle," one would hesitate to say that Ingres himself shows a greater insight into the nature of design. A few years ago, André Derain observed the likeness between this picture by Corot and the Mona Lisa, and the best men in Paris applauded when Derain said that the modern work could hang beside the old one. Yet, with all of Corot's debt to his Italian journeys, he is less concerned with Renaissance style than is Ingres: it is a more purely French tradition that we feel in him. His landscape descends from the lovely glimpses of the countryside in Foucquet's

pictures as well as from the classical compositions of
Poussin and Claude. His sense of form does not tend
toward the arabesque with which Raphael crowned
Italian designing: the mere mention of that art shows
us how directly Corot belongs to his soil, to the race
which brought forth the brothers Le Nain, with their
homely positivism and with the forceful rendering of
solid and hollow that places them among the masters
of construction. As with them, we find in Corot the
abstract quality closely united with observation of the
concrete, of nature. Between the idealism of Italy and
the materialism of Holland this is the middle ground
upon which French art remains throughout its history.

Corot holds this balance to perfection, the other
landscapists of 1830 do not. Their love of nature is so
nearly their sole means of approach to picture-making
that they set down their vision of the skies, the waters
and the trees with only a slight consideration of the
form and color through which classical art reaches out
beyond the particular object to the general, universal
properties of the mind. Yet with Théodore Rousseau,
the fervor of the artist's nature-worship gives us a pure,
self-effacing work to which many a later man will
return in order to escape the vexing problems of intel-
lect and of tradition. Such questions pursue Millet,
even in his forest retreat, and, suspecting that merely
to recite the epic of the peasant is not to produce a
complete art, he strives to get back the drawing and
modelling that he remembers having observed, all too
imperfectly, among the giants of the Louvre. Dau-
bigny, Troyon and Dupré trouble themselves very
little over such matters; and while the Romantic ex-
pression of feeling still attains the dignity of an idea
in their solid pictures, one feels that with the next

narrowing of the landscapist's art, with any further loss of the classical qualities, we shall be faced with a mere copying of appearances, the thing taught in schools, instead of the creation of new values, which is the work of the artist. In America, the decadence went on more slowly, because the feeling for out-door scenery was so natural to an Inness or a Wyant that he could find in sentiment a veil which concealed from himself and his public the essential slenderness of his art. And so this group of Americans, believing deeply in its work, postpones our descent into the morass of sentimentality and materialism which awaited the men who attempted to continue Barbizon painting in Europe. To make distinctions between them and the weaklings who form most of the American school of landscape to-day would be unprofitable. Let us rather turn to the Dutch painters and observe the one who, in the earlier nineteenth century, went to France and entered the central tradition of his time. This was Jongkind, whose Northern sentiment for nature remained throughout his lifetime the force behind that superb painting from which the Impressionists drew certain elements of color and light for their immense investigation of those subjects. They would not, however, have found a sufficient basis for their work in the heritage from Romanticist nature-painting, and it is to another point of departure that we easily trace their beginnings.

Could there be any more dramatic proof of the suddenness of change in the modern period and its strength in meeting the test imposed thereby, than the coming of the Realists while yet Romanticism was offering its finest works? Delacroix was one of the earliest to recognize the great qualities of Courbet, but

it can scarcely be doubted that he saw also the opposi-
tion between those qualities and his own. Where
Delacroix lived so much with music and literature,
trying to make the processes of his craft equal the
certainty which the musical composer has of the re-
lationship among his elements, and studying the psy-
chology of the great dramas and poems in his desire to
keep his pictures on a similar plane of nobility, Cour-
bet enunciates his doctrine of painting as a thing of
the eyes and proceeds to copy peasants, rocks and still-
life objects with the one apparent purpose of enforcing
on the mind the fact of their existence. The marvel-
lous instrument of color that the science and the senti-
ment of Delacroix had evolved is discarded by the
rough mountaineer, who returns to a black-and-white
basis for the picture as best suited to his sculpturesque
intensity. Cézanne, who had been under the spell of
Courbet in early life and had imitated him as had the
other masters of his generation, said, towards the end
of his career, "It took me forty years to realize that
painting is not sculpture."

The contact with reality which Courbet afforded
was like fresh air in the lungs to men who, had they
continued with the dream of Romanticism after the
moment when it had ceased to be the dominant factor
of thought, might have fallen into decadence. A per-
manent, not a transitional figure, Courbet is typical
of France in the wealth of elements through which it
corrects excess, even as in his own case the classical
structure inherent in French art acts as a balance for
his study of appearances and keeps it from descending
to the worthless copying of nature of a later time. For
example, his "Woman with a Parrot," which has for
some years been loaned to the Metropolitan Museum,

is so complete in its phase of representation as to make casual observers think of it as a mere "Salon painting" of a beautiful nude. Zola, writing of the men who had fallen away from their standards at the exhibition of 1866, spoke strongly against the picture which, to-day, seems to most of us a superb masterpiece: its lines hold to a grand and pure design even while they partake in the work of simulating a thing in nature—the aspect of the picture which misled superficial judgments.

What misled them as to Daumier and Guys was of course the fact that those two masters worked for the newspapers and were thus looked on as outside the field of serious art. Corot and Millet knew that this was untrue in Daumier's case, Baudelaire and Manet judged aright of the worth of Constantin Guys, but even with such authority to recommend them, it was long before the world in general came to see past the phases of satire and illustration in their respective works, and appreciated the grand draftsmanship of the two men. Perhaps it is most of all to Cézanne that we owe our better understanding of both of them. For while we note how, in his early manner, he followed Courbet's passion for the existence of the object, we see also that he is influenced by the sense of form, the organization of form, at which Daumier arrived when his realism in the world of ideas led him to find for it an appropriate expression in the world of plastics. This is perhaps most strikingly evident in the rare sculptural work of Daumier. The consummate mastery of black and white, the unfailing incisive line which the earlier nineteenth century took to be attributes of a mere illustrator, are seen by the later time as having to do with something beyond the thousand

scenes of comedy or tragedy which had chastened man-
ners with laughter—or with a scourge. Like Isaiah,
"he looked for justice, but, behold, oppression; for
righteousness, but, behold, a cry"; and even as no poet
would explain his love for the mighty cadences of
Isaiah in terms of the prophet's denunciation of evil,
so the artists love Daumier, not because he attacked
the weaknesses and wrongs in his time (already half-
forgótten to-day), but because of the force in the man
himself and of the art that carried the force into a re-
casting of the visible world—into the structure which
recedes with the valley where Don Quixote rides
with Sancho, or into the planes inciting one another
to a climax in the head of a politician rapidly modelled
in wax.

The subject matter in the art of Guys is outside the
field of polemics, and he seems to essay the rôle
of the "complete" painters even less than Daum-
ier; yet there is no less of intensity in his work and,
even while he remains the realist of the passing world
which he portrayed, one often finds an æsthetic quality
even purer than Daumier's in those drawings which
formerly were thought so slight. Once again time has
corrected a misunderstanding and we see that the few
lines which create the solid figure of some girl of the
dance-halls have all that is monumental in the drawing
of a great Florentine; Meier-Græfe has well observed
that the style in Guys' drawing of horses is like that
of the horses on Greek vases—and worthy to be com-
pared with those supreme things; when one considers
the order that imposes itself in the flying brush-strokes
as Guys lays on his water color, one perceives that there
is in the work of the old newspaper artist an intimate,
living design of the web and woof of the picture very

closely akin to that which we were to see in the paint-
ing of Cézanne. To realize this is to understand that
the realism of life and character in Guys as in Daumier
no more explains the greatness of their arts than does
Courbet's continuing preoccupation with visual ap-
pearances: the physical and intellectual world was the
object of their conscious study—their place in the Mu-
seum is among the masters of the classical values.

Undoubtedly the tendency to follow appearances
with the greatest possible accuracy, the searching out
of unexplored phases of sight, which occurs with
Manet and the Impressionists, is directly traceable to
Courbet, and it is health-giving for all who can use it
—and not be overcome. It affects even the two great
classicists of the time, Degas with his love of line—
a heritage from Ingres, his teacher—and Chavannes
whose preoccupation with composition causes him to
follow the early Italians so closely as to weaken his
own art at times. The career of Degas exhibits the
opposite development, for he went from pictures char-
acterized by the schoolman's withdrawal from life to
an ever closer adherence to Manet's slogan of "contem-
poraneity." Degas's choice of subjects—the famous
ballet-girls and race-horses, both in his painting and
in his magnificent sculpture—show how much this
master of classical form belongs to the period when the
idea of being of one's time was especially to the fore:
another aspect or consequence of Realism. Cha-
vannes had seen in his youth, upon contact with Cour-
bet, how inescapable the new vision was, and he fol-
lowed its development in the work of the Impres-
sionists. Yet his deepest concern was always with the
decorative and expressive sides of painting and, at his
best, his triumph in mural work is a noble one. If it

is not always sustained, if he inclines now to an appearance of conscious primitivism, now to literal representation that he attempts only with partial success to keep on the plane of his lofty idea, it is because there is a conflict among the elements of his art. Too much of a thinker on pictorial problems to adopt the simple formulas of Courbet, Chavannes had not the colossal instinct which carried the great realist over the insufficiency of his definition of painting—"a language whose words are objects." Returning to Degas, one asks whether the somewhat bitter tang of his splendid art does not come from the harshness of his effort to retain harmony between the æsthetic qualities which came to him from his schooling in the classical tradition—(one remembers his early copies of Poussin and Holbein, his life-long fidelity to Ingres)—and his contact with the world of sight,—which troubles him even while he studies it with the most penetrating attention.

How different is the whole hearted conviction as to the rightness of his work which carries Manet past all such vexation of spirit! A born painter, and born within sight of the Louvre, he goes early to the masters there for instruction in the positive and aristocratic style with which to attack the problem of the object at the point where he finds it in Courbet's hands. Though he has not the latter's grand singleness of purpose, he shows, by carrying realism onward into finer conceptions of color, design and technique, that there is to be no interruption in the line of creative effort. Secure in the control of his means, he makes excursions into the realms of Goya, of Hals, of Velasquez, of Raphael and of Piero della Francesca, and thereby sets all Paris in uproar—so strange do the masters seem when they walk the boulevards in modern attire.

But the younger artists are made sure of their direction by the audacious synthesis of the old qualities of the museums and the new visions of nature. By substituting the strong contour of the early Italians for Courbet's heavy modelling, Manet frees his color and brings it up into the light—not yet the perfect instrument which color will become later, with Renoir and Cézanne, but a rich and sonorous one none the less, whose effects of breadth and splendor are enhanced by the painter's unsurpassed vigor of handling. And his generous delight in the world about him infects the masters of the new generation with his confidence and sweeps them along in the *élan* of his irresistible painting. Yet with all of its fascination, it can not yield more than a momentary climax to the fecund, inventive period we are considering. Claude Monet still tells with relish of the way in which the young Impressionist group led Manet to accept some of their innovations in the painting of light; and he may well rejoice in his triumph of fifty years ago, for no incident in the record of his subsequent success could be more eloquent of the importance of his work than the influence which he and Pissarro and Renoir and Sisley could exert on that great painter with whose lessons they had begun.

The theory of the Impressionists—or their practice, as one may more accurately call it—has been described often enough for us to touch on it but lightly here. The indications of a truer rendering of luminosity by the use of color which the new painters saw in Jongkind, in Manet, in Turner, and especially in Delacroix, who provided their technical starting point, were carried to full affirmation. The Impressionists had no thought of creating a new art or a new science, as Re-

noir tells us in those recorded conversations wherein
he maintains that his group were followers of Corot
and that his own special predilection was for the art
of the eighteenth century. It is true that Monet and
Pissarro investigated the properties of the spectrum
with a view to greater accuracy in the painting of light,
and that they made the momentous step of juxtaposing
in separate brush-strokes the elements of color obtained
by their analysis of full light, passage, and shadow.
And when in their beautiful pictures they have given
to the palette its maximum of richness, employing
shades that seemed possible only to the enameller or the
mosaicist, the full diapason of the sunlight floods their
canvases as it had never done in the works of the Old
Masters and we have at once the final expression of the
modern love of nature and the furthest point we have
reached in our representing of appearances. Even in
achieving such things, Impressionism, through its
search for the facts of sight, was still obeying the dic-
tates of Courbet, and its findings did not attain full im-
portance in the building of pictorial structure until the
intellect of Cézanne and Seurat had changed the in-
stinctive painting of their immediate predecessors to a
thing of conscious purpose. That which is necessary
here is to show what phases of Impressionism caused
the later men to depart from it and even to adopt a
procedure directly opposed to that of Monet and his
group. Perhaps the deepest reason is that, after all,
Impressionism did not so much give the world a new
conception of nature as a new method of representing
nature. If one thinks of the change from the
eighteenth-century convention of landscape brought
about by men like Constable, Corot and Rousseau, one
has an example of the *idea* in art, the idea that creates

a new vision. As the Impressionists divided colors into their components, so they divided up the great Naturalistic vision of nature according to the effects of sun, mist, etc. They enrich us through their personal intensity rather than through a new idea—their fruitful color-analysis being a thing for the profession rather than the public.

Without the color of the painters, one sees impressionism in the manner with which Rodin, the sculptor of their generation, conceives his art. He not only brings light into the marble, but studies each bit of the surface with the minute attention that Monet or Sisley would give to analyzing the blue of a sky or a shadow. One feels the very pulsation beneath the skin, and the warmth of the flesh so carefully studied in relation to the bones and sinews by this "intimist," as Rodin has been called. But he seems to know that his concentration upon the parts of his statue is robbing it of the unity, the monumental mass, which should be one of the chief qualities of sculpture. And so he makes those thousands of drawings wherein the whole of the action is seized with one sweep of his pencil, with one wash of his water-color brush. He used to speak of them as the most personal achievements in his whole art; and yet when he returned to his clay, the synthesis of the drawing has disappeared, except for the matter of its sentiment, and he is again caught in the complexity of appearances,—his mastery over modelling, however, and his superb energy saving him from the pitfall that engulfs the mere copyist. By the later 'eighties there was a deep consciousness among the younger men that the long slope of Realism had been climbed; and that is why they turn so sharply to the intellectual, constructive art of Cézanne, to the exotic

design of Gauguin and Matisse, to the world of the
mind opened up by Redon and explored with such
unexpected effect by the Cubists.

But as we are to-day passing through a moment of
reaction from the Impressionists, let our final glance
be at the achievement of their greatest painter—Re-
noir. Follow him from the early works preferred by
those who care least for him, to those productions of
his old age wherein his art is purest, and you see the
essential development of the artist, from painting in
which the object is represented in all its phases—with-
out the special emphasis which means intention and
expression—to a concentration, in his later work, on
design and color from which the dross of materialism
has been burned out in the fire of one of the world's
great geniuses. He makes us think of Rubens by the
infallible mastery with which he makes the mysterious
wave of color turn and recede and come to climaxes
and pass on again, effortless and harmonious as the
sound of a great orchestra. But he is what even Ru-
bens is not—a Latin, with the heritage of three-
dimensional design which Frenchmen, from Poussin to
Derain, have been bringing from Italy, and which Italy
carried on from Greece. In the old age of Re-
noir, most of all in his old age, I think, there is that
unquenchable youth of his ancient country, always
thrilling to the beauty of the young faces and bodies
and flowers of which poets and artists have been sing-
ing ever since they had voices at all, about which the
museum makes weak men think there is no longer a
fresh word to say, but of which the miraculous, renew-
ing strength of the modern period gave us, in Renoir,
a new symbol.

THE POLES OF THE MODERN
MOVEMENT

CÉZANNE and Redon are so obviously different from the Impressionists that it can not be other than a surprise to one who knows their work and not their history, to find that they are exactly contemporaneous with that group. Cézanne was born in 1839, the same year as Sisley; Redon in 1840, the same year as Monet and Rodin, and one year before Renoir. The early work of Cézanne fits in perfectly with the Courbetesque and Manetesque painting of the Impressionists among whom he began, and it is not until he is nearly fifty years old that a fundamental difference between his work and theirs becomes clearly apparent. Redon, on the other hand, is marked for his life-work from his earliest pictures, and it is only through certain qualities of color in his later painting that we can see any relationship between him and his great contemporaries—who were his friends and admirers. It is natural that we should think of Cézanne and Redon as later men than the Impressionists, for the world did not appreciate the significance of the two masters until long after Monet, Pissarro and the rest had achieved fame and influence. There was nothing of accident in this, for the Impressionists furnish the last chapter of the scientific and realistic effort of modern times, while the two painters we are to consider initiate the departure from it.

Cézanne and Redon are not merely different from their contemporaries but from each other, diverging,

as they grow older, until we may look on them as the poles between which the modern movement has since oscillated. In the words of a Dutch critic, they divide the heritage of Delacroix—Cézanne developing the qualities of form and color of the older master, Redon carrying to new conclusions his research in the world of vision. In both cases one traces these tendencies farther back than Delacroix, but the essential difference between the two masters lies in the direction they gave to their work, and not in the fact that Cézanne is by far the greater artist.

In the time to come, when the struggles of the nineteenth century are forgotten, his place in the classic line will be even clearer than it is to-day. Yet even to-day any collection of his work showing his full development carries us almost unaided from the heavy modelling of the Realists and the fiery imagination of Delacroix, through the exploring of light and color which he made with the Impressionists, and so to the threshold of the ideas of to-day, most of which are contained, in germ at least, in his later work. Though we see him now as the same man from the first, it is evidently the Cézanne of the twenty years or so before his death in 1906 whom we must study more particularly.

Yet to regard the later phases of his work as something which he evolved unaided after he left Paris in the early 'eighties is to forget the magnificent quality of many an early picture and to miss the connection between him and the great men through whose influence he passed. Indeed it is important to follow him from the first of his painting, from those works wherein we see the old instinct for harmony that still dwelt in the classic soil on which he was born. It

is the part of France where, as Elie Faure has shown, the Greek genius gave some of the finest manifestations of its later power, as in the Maison Carrée of Nîmes and the Venus of Vienne. While the sense of measure in Cézanne's later work constitutes the most intimate bond between him and the classics of antiquity, one may see, without too great a play of fantasy, some of the ancient love of rhythm in the flying draperies of those allegorical figures due to the instinct of the young painter. Soon a more turbulent note announces his contact with Romanticism (his study of Delacroix's color will come later in his life), but the decisive influence of his early period is that of Courbet, and his "compatriot," as he loved to call Daumier— who was born in Marseilles—also pointed through his work to the importance of reality. For years he works at his investigation of the aspects of sight which give us the sense of solidity in the painted object, and so in later life, even when he is least concerned with exactitude of representation, one has the conviction that the forms in his pictures are based on sensations of the weight and existence of matter. Then, with Manet, whose work finds a generous and worthy response in his own, and finally with the younger men—among whom the thoughtful Pissarro is his closest friend—he adds to his equipment the new ideas of color and light, which he did his share in developing, during his Impressionistic period and after it.

When he is ready to withdraw to Aix-en-Provence, his native town in the South of France, he carries with him an experience even more valuable than that of the contact with his century: it is his study of the Louvre, which is henceforth to serve him, and be linked with the *"bonnes humanités"* of his youth. The Greek and

Latin poets whom he loved to quote never had worthier homage than the painting of Cézanne. In the phrase of his which is most often repeated, that which explains his purpose of "making from Impressionism something solid, like the work in the museums," of doing over the work of Poussin from nature, he might have named other masters as well as the one who, for Frenchmen, epitomizes their classical heritage. With Signorelli, whose figures he copied and used over and over in his pictures, he touches the Renaissance at one of its highest levels; and numerous drawings from the Greek sculptures in the Louvre attest his study of the central focus of European art. On his wall hangs a water-color by Delacroix; in his letters we find references to Tintoretto, the Spaniards and Chardin.

He continues to paint from nature until the end of his life; but the slightest sketch of his later years shows his growing preoccupation with the æsthetic qualities of the picture. Herein lies the difference between him and the Impressionists. With the latter one feels that the limits of the picture, and its subdivisions, were imposed from without, by the aspect of the scene portrayed; the oppositions of the colors were used to produce effects of luminosity, again an external thing: what gives the picture its life is the splendid instinct of the artist who transcends his theory in the excitement of his work. Even Renoir, when questioned about painting, preferred to go on farther than the statement that it was a means of transmitting the passion that is in the artist. Concerning the way in which this is accomplished, concerning the laws certainly recognized by him as underlying the works he loved in the museum (which he considered the sole teacher of the artist), he was silent. Cézanne's immense author-

ity proceeds precisely from his having rendered comprehensible to the next generation the laws of picture-making which the haste and confusion of the nineteenth century had obscured. Needless to say, these laws are such as can never be written down; they are the principles, perceived by the mind without the intermediation of words, which govern the productions of the masters of all times and races, the principles which differentiate the work of art from everything else in the world.

Before the French Revolution, the reign of law in art was so easy and natural that men could paint or carve without the consciousness of doing anything but imitate nature. Leonardo himself, the most inquiring and profound of men, has certain passages in his writings which, considered apart from others which modify them, directly affirm that the rôle of the picture is to be a copy of a given person or landscape. When hatred of the eighteenth century appears with the Revolution, David feels that something more imposing than personal preference in art matters is needed to give authority to his ideas and he invokes the law derived (according to his own lights) from the Greeks and the Romans. Thenceforward—through Ingres and Delacroix, through Courbet even, most of all through Cézanne, and so down to those who learn his lesson and that of Redon—there is a constant, and increasingly conscious investigation of the properties of the work of art—the Museum being, of course, the field where the research is conducted. The greatest significance attaches to the fact that every master of the modern time has executed copies in the museums, usually from works of widely varying character, and not alone during the student years when the Old Masters

copied to learn their craft, but during maturity or even old age, when the hand was no longer to be influenced but the brain was still tirelessly seeking to know the truth. Why did Veronese use the two opposing colors in the collar of that man in the "Marriage at Cana"? asks Delacroix; how are we to explain the fact that a similar sequence of hues appears in the drops of water falling from Rubens' nymphs? he inquires again. Or, when a bright yellow cab drives through the street he was observing, why is it that he now sees violet tones in the shadows on the pavement, where before they had been blue? And so, later, when the problems of color had to some extent been resolved, Cézanne inquires into the effect on the lines and planes of a picture when a new horizontal or vertical or oblique line or plane is introduced. This outer world that seems to the careless observer so settled and static is, then, in a constantly dynamic state wherein nothing is isolated or inert—where everything is affected by the forms and colors of all the objects within the scene. As the modern period's growing skill in representation turns the pictures at the academies into simulacra of nature containing less and still less the quality of life, when such counterfeit art gains more and more in prestige with the modern mob in its growing ignorance of the classics, the young painters who have still (and how powerfully!) the instinct for the æsthetic qualities, turn to the man who above all others among their contemporaries was applying the law learned at the Museum to the chaos in the world around him.

Cézanne, superimposing color upon color to get their cumulative effect, watching the reverberation throughout his canvas of each new touch, was performing a mental operation similar to that of the mu-

sician, whose material, farther removed from the imitative than is the painter's, arrived much sooner at its purity as an agent of expression. Since form, more than color, renders the thing seen, Cézanne's organizing of the lines and planes of his pictures will stand as an even greater achievement than his work with color. A certain latitude has usually been permitted the colorist in his search for harmony—which has been pretty generally understood as the object of his effort. But drawing, "the probity of art," was another matter. For many hundreds of years, since the decline of Byzantine art, Europe had been working for an evergreater completeness of representation; and Cézanne himself, when his need for an æsthetic structure forced him to modify, in his painting, the physical structure of objects, was tortured with doubts about his procedure. Yet he went on, always in the same direction, making a constantly more rigorous elimination of the sensations which to him represented only accidents of vision and which were not essential to the new organism he was building up. The thrill we get from his later works comes from witnessing an act of creation, from being associated in imagination with that act. Every line, every plane, every touch of the brush works together with the rest as the muscles and nerves of the body respond to the impulses of the mind. It seems to many men to-day, though it is dangerous to make extreme statements about a contemporary, that neither Michael Angelo in his mastery of form, nor Rubens in his handling of color, has gone farther in this respect. What one may affirm without confronting artists so different from one another and so sufficiently equipped for their own problems, is that with neither of these

earlier masters are the vital elements of the picture so directly accessible to the eyes of our time.

One sees the pictorial elements unmistakably in the water-color sketches of which Cézanne made so many. First come the large divisions of his subject, established with a lead-pencil. Then come accents of the parts, obtained with the brush, certain dominants of form or color being insisted on from the start, while the less important notes are held subordinate to them. The work may be laid aside at any time and be complete even when, as occurs quite often with these studies, one finds it difficult or even impossible to recognize the subject. Cézanne never went to the length of deliberately suppressing the aspect of natural appearances; he was, after all, a man of the generation which set itself to represent them most fully. But as he grew older, the underlying laws of sight and of harmony came to interest him more than their application to the representing of objects, and so we get those pictures wherein a space of nearly bare canvas will be bent into form by the action of its contours (the highest conception of form, as we see with the Florentines or with Holbein), where heads are without features or where masses of foliage come forward without apparent explanation of their source, because the painter, having obtained the volume he needed in his design, did not feel the need of going into questions of representation which were irrelevant to his æsthetic purpose.

Probably in the whole history of art up to his time no one had ever set himself this purpose so unrelentingly. To compare his painting with the work of the architect or the rug-weaver is misleading, for the spe-

cial function of their products gives them a different basis of judgment; and if I permitted myself a reference to music, a little earlier, it was only to make clear the distinction between representational and expressive material. Cézanne's preoccupation with law has made a recent painter of great importance refer to him as ascetic; and if one thinks of his work beside Rembrandt's, the warm human sentiment of the Dutch master may seem at first to justify the charge. Let us rather say that the comparison (if comparisons of the masters are to be permitted at all) makes us feel again the strength of our period, which could bring forth a work consonant with the findings of the past and through it lay open to us a horizon of painting only half perceptible in the art of the past. Certainly, every man of importance in the younger generation has acknowledged this work as basic; and yet it is not sufficient to explain the art of the present day, as Duchamp-Villon once remarked to a painter who said that he had reached an appreciation of Cubism through copying a Cézanne.

As little as the abstract painting of recent years resembles the work of Odilon Redon, we shall see later that before the new conception could arise, it was necessary that the idea of the great visionary be assimilated along with the sense of construction due to Cézanne. Like Cézanne, Redon is too much of his time entirely to abandon the world of sight; yet his art is located in the plane of the mind, as against the physical world with which our realistic age was so concerned, almost more completely than that of Cézanne, whose work always contains a direct reference to the substance and the light of nature—and loses nothing of freedom thereby. Redon has told us in

words (see the collection of his writings, "A Soi·
Même"), that the reality at which he aims is not the
one obtained through perspective, chiaroscuro and the
other means of representing the thing seen. For him,
true existence is not conferred on the visual image be-
fore the mind has fused it with imagination and pre-
vious experience. It may be said that this is true for
every artist; what distinguishes Redon is his having
formulated the theory and so reached a special free-
dom in pursuing it almost to the extreme limits that it
allowed.

Like Delacroix, his favorite among French artists,
he lived much with books and music. Mallarmé and
Huysmans were his intimate friends, and he was one
of the first men in his country to appreciate the great-
ness of Brahms. Undoubtedly his communion with
them strengthened his love for the world of vision and
hastened the evolution of his art. In certain early
etchings there is an exact notation of landscape de-
tails; all through his life it was his practice to make
studies from nature with the closest visual fidelity—
and with a skilful hand. Yet even these works, a
preparation for his more characteristic production, are
part of his dream. They stand apart from the paint-
ing of his generation, as one sees at a glance if one
places his most objective effort beside any other pic-
ture of his time. The case is the same as that of the
naturalistic studies of Dürer, which are felt to be
touched with the visionary quality of his whole art.
The "Melancholia" of the great master of Nuremberg
was an ideal with Redon. The "literary" quality of
that engraving was no obstacle to its reaching an ex-
traordinary level in plastics; so also Redon's constant
preoccupation with the significance and symbolism

of his subjects should blind no one to his æsthetic achievement. A severely blocked form, establishing the great masses and angles and proportions, upholds his draftsmanship in its wildest flights; and his color, even more a thing of the imagination than his line and composition, has an unearthly glow that makes one think of the old enamellers and mosaicists. If Redon belonged to their distant epoch we might estimate his value more easily. As he is of to-day, we are constantly tempted to make baseless comparisons between him and his contemporaries. The very force with which the latter swing us in their direction is the measure of Redon's originality, since he could breast such an opposing current and keep to his own course; and we see in the character of the period as a whole our need of the reminder, given us by Redon, of that world beyond the world of the eyes, which, on rare occasions in the Occident, but times without number in the Orient, has been the subject of the artist.

AFTER IMPRESSIONISM

In one of his writings, Redon asks himself why he found such difficulty in getting started on his work, and we know that Cézanne was, throughout his lifetime, puzzled and mortified by the fact that his art was so slow in finding recognition. To-day we can see that the reason for the two things, which are the same thing, lies in the greatness of the art immediately preceding their own and in the extent to which they changed men's ideas. The painters we have considered thus far, and Seurat whom we reach in this chapter, are not merely artists of genius, they are turning points in the art of their time; and this can scarcely be said of the first painters to appear after the generation of the Impressionists.

In Gauguin and van Gogh we have personalities of unusual distinction: Gauguin, who was an almost fantastic character, with his Peruvian blood and his Parisian youth, his generosity, his wildness, his need for the exotic, and withal the quick intelligence which the Impressionism of his first years as a painter whetted to a keen edge; and van Gogh, whose character is manifest from the most summary review of his career, its acts of faith and heroism, its fire sweeping on in the ever increasing heat and light which we see in his pictures.

Yet the passing of the years, while it assures the place of these artists in the history of their time and in the affections of men, tends also to convince us that they are not the equals of the greatest men of the mod-

ern period. Perhaps one makes the admission with most regret in the case of van Gogh, whose art is of such moving beauty that it seems mere pedantry to ask what ideas he offered the world that it did not have before. If the findings of art, like those of science, became part of a common treasury to which each succeeding master contributes and on which all draw according to their needs, the task of the critic—now nearly hopeless if he aspires to definitive pronouncements—would be a simple one. But the line of evolution that I am following in this book is essentially hypothetical—a temporary convenience in a discussion whose real object is to awaken a sense of the immense energy of our epoch and to stimulate a wider recognition of the greatness of its achievements in art, our final purpose being to arrive at an ability to appreciate the masters of to-day. Considering the great artists in perspective, one perceives continuity and interdependence among them. Had Courbet not produced the work which so influenced Renoir in his youth, the later production of that adorable painter, fine as it would have been, could not have had the special character which we know. The contribution of ideas is, therefore, a legitimate criterion in forming an appreciation of an artist's value and has some bearing upon the question of his genius, even though we admit that this, in the last analysis, can not be defined.

One may hold in contempt the fortune-teller's tricks for casting a horoscope, and yet notice that for over a century it has taken the world about twenty years to assimilate each epoch-making idea in art. Until the idea is worked out, men can not leave it in order to evolve a new one; and afterward it is without generative power. There is almost complete agreement con-

cerning the masters of the earlier epochs of modern
art: Classicism (with Ingres, born 1780); Roman-
ticism (with Delacroix, born 1798), Realism (with
Courbet, born 1819) and Impressionism and its reac-
tion (with all the masters of the group born between
1839 and 1841, save Pissarro who came from the
colonies and therefore began his work later in life
than the rest). Between each of these movements and
the next the interval is within two years of the twenty
I have mentioned; just twenty years after Cézanne's
birth comes that of Seurat, whom the wisest critics
to-day consider the great man of his time; while De-
rain, Picasso and Braque, undoubtedly the most influ-
ential men of the present generation, were born
respectively, twenty-one and twenty-two years after
Seurat. There is here either a remarkable coincidence
or else—as I believe—a genuine indication that the
mind of the world has its periods of greater and lesser
energy; and the impressions of an artist's youth,
falling within one or the other of those periods, deter-
mine the character of his achievement. The rule
is too liable to exceptions to offer more than probable
evidence for the idea that Gauguin and van Gogh,
born about midway through one of the twenty-year
periods, are less great than the men who came before
and after them. There is, however, one sure deduc-
tion to be made: that the modern period, rich as it is,
has had moments of respite, during which no new idea
appeared; and this is of interest to-day when we have
seen the rise of no master for ten years or more, and
when the usual cry of decadence is being raised.
Some people try to meet it by mentioning the war; but
that event, however stupendous, has probably had but
little effect on art. A better reason for the present

state of affairs is to be found, I believe, in the periodic action of thought in our time.

Returning to the artists who first engage us after the generation of the Impressionists, we may recall that the latter exercised a formative influence on all three of them. Van Gogh and Seurat adopted the ideas of the Impressionists only after an early period in other schools; while Gauguin, whose art was to differ most in appearance from that of the older men, adopted them at once, his closest model being Pissarro, whom we find so often as a giver of ideas. But soon it was evident that those ideas had yielded to the generation that had evolved them, all the results they could produce. Weaklings might try to gild the refined gold of the Impressionists; men of Gauguin's stature moved to new fields.

"Le Christ Jaune," a painting of his Breton period, shows the influence of the art descended from the Middle Ages, whose picture-making, as represented, centuries later, by the Images d'Epinal and other popular prints, was eagerly studied by him and the younger men who soon grouped themselves around him. Their instinct for an art that offered possibilities of development, had led them to a school distinguished by religious expression and by design, qualities that had been absent from the work of their predecessors. But Paris and its life and its art were still too near for Gauguin, and he took refuge from them in the South Seas. The voluptuous "island of odors" (Noa-Noa) taught him what expressiveness the Tahitians could impart to the broad sweep of line and surface of their wood-carving. In the instinctive art of these primitive people he found relief from the intellectualism of Europe, and inspiration for the decorative painting for which he was so

remarkably gifted. In an age appreciative of its artists he would have been allowed to make free with the walls that he always longed to work on, and that he would have treated in more original and vital fashion than Puvis de Chavannes. His easel-pictures now seem to most of us beautifully patterned illustrations of the romance of the tropics rather than creations which exist independent of the world of appearances, as works of the finest type do. Nevertheless, Gauguin's art is so genuine, so much the expression of a man who loved life and his work, that it can scarcely fail to give pleasure to the future. His immense interest for his time comes from his recognition of its need to recombine into a pictorial scheme the elements revealed by the analysis of the Impressionists. If his personality and his decorative talent did not carry him entirely through the difficulties of that big task, if he is not of the main stem of modern art, he is a branch that bears flowers of a rare perfume and that later men have not neglected.

With Gauguin we are still thinking in terms of æsthetic theory; with van Gogh it is the drama of human life that thrills us. His own drama ends in a tragic death, but his life was one of triumph. Its external circumstances were of the bitterest; but no painter would look on that as more than a cheap price to pay for the chance to give color such resonance, to illumine faces with so much expression, to cause light so to kindle on gray canvas, and to capture space and atmosphere through the little ink- or pencil-marks which our race has been studying for so many thousand years.

Again and again we are startled by the technical ability of van Gogh. But his knowledge of the color that will inflame another, the certainty with which he

makes the whole work quiver with the fierce rhythm of his painting, yield something very different from the performance of the virtuoso. His certainty is only the outer indication of his belief in his vision, in the magnificence of the thing presented to us, in the miracle of living, before which differences of mentality, character or position sink into insignificance: his postman is a king or a prophet; the wife of the café-keeper ("l'Arlésienne") is marvellous with all the mystery of womanhood, and the splendor of purple and green and rose with which he surrounds her make their unforeseen and stirring harmony because in this work, as in all his work, the artist's whole life is pouring forth in that love of the world and its people which we gather from reading his letters, with their schemes for bringing about a brotherhood of mankind, with their anguish, their return to hope, and their unquestioning belief in the art which he finally reached, and in which he expressed himself as fully, perhaps, as ever a man has done. In his days as a clergyman he had found words too weak for his idea; as a painter, he seizes it passionately and unerringly.

The world could not live on at such a *tempo,* and with Seurat it gives us the most severely intellectual genius of modern times. He is not cold: it is passion —the intensity of his feeling for nature and for art that keeps his mind on its plane of faultless logic, that informs his color and gives it the cool clarity of the skies of his northern France. The same passion raises his form to the grandeur attained by his ancestors when they built Notre Dame in the city of his birth. In his last work, "The Circus," one has even the illusion that he is engrossed merely in his subject—the ring, the flying white horse, the elfin dancer on its back, the

painted clowns, and each one of the commonplace and
fascinating personages of the audience. It is only
when an artist is in full control of his means, that he
can do work of such apparent simplicity. Fra Angel-
ico's absorption in his themes was possible because a
long line of artistic ancestors had placed in his hands
the perfect instrument for his work—an instrument
which the innovators of the Quattrocento were soon
to transform again. Like him, Seurat also receives
an art at its moment of full development, the splendid
painting of the Impressionists. He is not dazzled by
its brilliance, but calmly determines the next step
needed in the evolution which, as he sees, is not yet
ended.

Even in his earliest years as an artist, when studying
at the École des Beaux-Arts, his faculty for investiga-
tion is evident. His teacher, a pupil of Ingres, passed
on to him the principles of drawing inculcated by that
master. We know the decadence of these principles as
handled by at least two other students of the atelier—
men who saw the line of Ingres not as one of the great
elements of art but merely as a means of copying na-
ture. For Seurat, drawing is, from the first, a thing
governed by its own laws—which he sets himself to
discover. In hundreds of studies—of people and of
landscape—we see him searching out the relationship
among lines, curved and straight, horizontal, vertical
and slanting. At the end of his life he writes down
in words how each of the abstract qualities he evolves
is used by the composer of pictures, as also the æsthetic
rôle of the lights and darks. As the result of his meet-
ing with Paul Signac, the admirable painter who ini-
tiated him into the new ideas of the Impressionists,
Seurat schematized the qualities of color as he had

previously done with those of line—and of this he also tells in the letter I have cited.[1] As it is the heritage from Ingres which underlies his analysis of drawing, so in the study of color he and Signac consult Delacroix, the master who inaugurated and indeed almost dictated our whole latter-day understanding of color. In explaining to themselves the grand effects in Delacroix's decoration at the Louvre, "Apollo Slaying the Python," in the paintings at St. Sulpice and in the smaller works, the young painters find invaluable confirmation for their ideas in the "Journal" of the artist who had penetrated deepest of all to the law of harmony, and laid bare its working in those late pictures of his where the colors, juxtaposed in almost separate strokes, permit us to follow his theory of the relationship among the hues. The scientific spirit of the later generation must needs, however, go farther than the results obtained under the inspiration of Romanticist enthusiasm, and so the books of Helmholtz, Chevreul and Rood were consulted—the findings of the laboratory being used to corroborate and assist those of the studio. Then, the varying tendencies of the time being harmonized—the line and color of the earlier, more idealistic men and the fidelity to appearances which grew out of Realism—painting had, with Seurat, a moment of perfection and repose similar, as I have suggested, to the unconsciousness of effort with which Fra Angelico went from one masterpiece to another in the cells of San Marco. The work of Seurat is no less beautiful; indeed, as men of our time, we may be permitted to enjoy even more fully the pictures of the modern master.

[1] The letter is reprinted in my study of Seurat, which is included in the bibliography at the end of this book.

They are few in number, partly because of the short-
ness of his life, partly because of the wealth of detail
and the infinite care he bestowed on the six large
masterpieces which, with certain smaller pictures
(often no less perfect), make up the body of his work.
"La Baignade," his first important painting, is built
on static lines of a calm grandeur for which there is
no precedent in the modern time. Less remarkable
for color than the later work of Seurat, it is already an
example of his capacity for obtaining in the minutiae
of his picture as well as in its general effect (the tiny
triangle of the sail in a corner of the composition as
well as the nobly drawn figures in the foreground),
that ultimate rightness which convinces one that the
artist has grasped and expressed the whole of his idea.
"Un Dimanche à la Grande Jatte" follows; with its
perspective of tree-trunks like the columns in a cathe-
dral, with the color kindling in the light which the
painter now understands better, with the purity of
form in the figures, and with the hieratic rhythm in
the draperies, it is perhaps the work in which we best
see Seurat as the student of the Louvre, for such
he always was. Going on to freer conceptions and to
severer execution, he arrives at the great canvas of
"The Circus," in which his æsthetic qualities are at
their fullest expansion, where the rigorous planning
of each curve and angle, and the uncompromising
division of the color are masked, for the layman, by
that amazed delight in the spectacle through which
the artist—so old in experience if not in years—rejoins
the child in his viewing of the world.

Again changes were at hand. The scientifically ac-
curate accounting for every phrase of appearances,
which Seurat (together with Signac) brought to its

final point, demonstrated for the next group of men that art, which is infinite, could not be contained in representation, which is finite, even though the two can exist together in one work. Also, when Seurat had showed that it is with the properties of form and color that the strongest effects of the artist are obtained, the way was cleared for our latter-day investigation of these properties, in complete independence of the recognizable object.

Every so often one hears the statement—"I am in favor of the modern artists—the real ones; I was of the first to defend Manet and Monet; but these painters that people are trying to make us accept to-day are quite different." And indeed they are, except that they are the artists of to-day as Manet (who died forty years ago) and Monet (still with us and painting, as one rejoices to hear, but eighty-four years old) were the artists of their day. The error of the man who makes a remark like that cited above is, of course, in failing to notice that the aspect of art which was new in his youth is no longer new,—that there is not an artist in the younger generations who can any longer do living work with the Impressionist idea. Perhaps in the new period we are entering, when all that is now called modern painting will be a thing of the past (the glorious past), the evolution of art will go on slowly and in the straight line followed by the eighteenth century, for example. But nothing is more certain than the fact that in our time the changes have come quickly and that the line makes sharp turns. Claude Monet tells how Corot, coming out from an early exhibition of the Impressionists, was as nearly in a rage as was possible to one of his gentle spirit. For once he used harsh words, about "ce tas de jeunes fumistes."

That seems strange to us, not only as language coming from the always kindly old artist, but because in the years preceding his death in 1875, Monet, Pissarro, Renoir and the others were painting pictures which to-day look so very traditional, so obviously the next step from the work of Corot himself, whom all the younger men revered. But they had made the step, and that was too much for human nature, even that of a Corot,—whose benevolence toward his imitators sometimes led him to sign the works they brought him for correction—and for the signature which would then fetch a round price.

To-day when the position of Cézanne and Redon is scarcely less assured than that of Courbet, when Gauguin, van Gogh and Seurat are rapidly being submerged in the ever-advancing wave of the accepted and canonized, one asks oneself what new direction appeared in the art of the late 'nineties and the first years of this century which could win for its producers the title of *"les Fauves"*—the Wild Beasts—and give it the special quality that still seems fresh to-day, even though two movements have appeared since. Here at last is modern art, says some reader who has waited patiently to get done with the talk about the pictures of fifty or seventy-five years ago, "things that anyone can understand." Are old pictures really better understood than modern ones? Only a little, I believe; they are more familiar, more accepted, but as mysterious, essentially, as the works of our own time. At all events, if anyone thinks there is a fundamental difference of purpose between the old and the new, let me refer him to one of the most admirable articles on art that has appeared in many a day—the one contributed by Henri Matisse to the *Grande Revue* of

25 December, 1908. Reading it, one almost thinks that the writer is taking a mischievous pleasure in disconcerting an audience assembled to hear him roar and howl, as befits a wild beast; whereas his words about the old themes of color, composition and expression are traditional in the severest and best sense. He is conscious of his effect and replies to the criticism of it by saying that there is never anything new in art. Later on, echoes of this statement came from people who, after having admired his originality, or after rebuking him for a pretence to it, discovered that Matisse had not done such unheard-of things after all: witness the portraits in encaustic of Alexandrian Egypt, the painting of the Persians or especially the frescoes of ancient Crete. As for Georges Rouault, that other wild man, the superficial observer would ask, wherein was his work essentially unlike what had been shown us ages ago by Daumier—or was it by the glass painters of the cathedrals? And Derain and Dufy, had they done more than follow the hint of Gauguin (who probably had it from Manet), that a whole treasury of new material lay stored up in the old French prints that were produced in great numbers for the houses of the poor?

All this has truth in it, but more than this must be said in order to explain why these painters gained their prestige, why their admirers see them as the true inheritors of the great past, and why the direction taken by the following group is inexplicable without them. The answer to these various questions seems to me to appear of itself when we recognize that the period which *les Fauves* inaugurated is one of conscious purpose, as compared with the more or less complete reliance on instinct of the time before.

Certainly such a development does represent one of those sharp turns in the line of evolution which I mentioned before. The step which we saw as too strange for Cézanne and Redon to make in their realistic period is now taken by the new men. For them the significance of the previous work has become fully apparent. Cézanne had said that painting from nature did not imply copying the object but realizing one's sensations. Yet he himself continued to keep the object well before his eyes, and spoke severely of Gauguin and van Gogh, whose formula for nature contains less of the object than does his own. Had they been his equals in personal greatness, he would probably have been no less troubled by their innovations; indeed he dismissed all the artists after Impressionism with the words "they do not count." The trouble was that the younger generation had found a different formula for "realizing sensations." They knew so well that this was the problem of the artist that they consciously accentuated what were to them the essentials of their pictures and consciously eliminated what seemed merely accidental. In the art of the Gothic or—even more, the Romanesque sculptors, or that of the Hindus or the Africans, in Persian and in Chinese painting, the convention is arrived at through the slow growth of tradition, and through racial habit and preference. In the work of the Fauve group, the convention (and of course all art implies convention) is reached in a short time, as men realize that unaided instinct will no longer guide them safely.

The older arts I have just mentioned are eagerly studied, while among the moderns, Seurat offers to the younger group his analysis of the picture and his clear knowledge of the separate elements to be re-

combined into a new synthesis. But the world was ready for far greater consequences of his idea than his pictures at first seemed to indicate. When Seurat died, in 1891, Gauguin had not given much more than a hint of the expressiveness of the design which the non-realistic art of the primitives had taught him. Van Gogh's work was done, but it was hidden away for several years after his death, and only then began to make artists and public aware of the directness with which its flaming color externalized the passion of the man. Above all, in 1891 Cézanne had scarcely entered upon the development which was to influence the new generation most deeply—that extraordinary series of pictures in which we can all see to-day that he was evolving as the material of his art a structure of form and color derived from the laws of the mind which he saw incorporated in the works in the museums, and was using the appearances of nature as means for his research.

It is because the movement of *les Fauves* synthetizes these elements that we regard it as the next step in the evolution of modern art. Its argument (offered in no manifesto but deducible from the work) would be that the expressive and æsthetic qualities being the essential of the pictures of the preceding school—or rather of all schools—it is the artist's business to pursue form and color and expression, to make them unite indissolubly into a work of art, something belonging to a different sphere from that of the vague abstraction which we call Nature. Art defines our sensations and is the means by which men know one another: nature is seen by different epochs, different races and different individuals as an infinitely varied thing, one that is known, after all, only as shaped and colored by the

preferences, prejudices, mood and experience of those
who look on it. But take men like Rubens or Char-
din, some one would object; is there not in their work
a phase of nature as we all see it, as well as the
æsthetic qualities which we agree on as essential?
Yes, a phase, if you like, or to be more exact, various
phases; and a Leonardo or a great Chinese artist
would offer quite different phases, and a Holbein or
an archaic Greek vase-painting still others. Each
time that a master has made us see something that we
had not seen before, we call it nature; and if we do not
stop to consider, we have the illusion that this thing
has been defined and is unchangeable—but that is
only illusion. The measure of a new art, the thing
that makes the difficulty about appreciating it, is the
extent to which it changes our vision.

The tremendous movement of thought which began
coincidently with the French Revolution had given
artists the power to change the vision of Europe again
and again in the nineteenth and twentieth centuries.
We have seen that Impressionism, as new as it ap-
peared at first, went more to surface than to depth.
After Impressionism (not to mention the weaklings
who merely tried to repeat the work of its masters,
even less to consider the poor, still-born things of the
academies, the magazines, the inferior museums and
the public buildings), the 'nineties brought forth a
group of men like Bonnard, Vuillard and Roussel who
tried to make their quite genuine sentiment and sen-
sibility do duty for idea. Lacking the larger, genera-
tive quality, they were like men living on capital—
a process which, in art, can not go on for long. Even
the resources of Renoir, Cézanne and Redon, upon
which they chiefly drew, existed only through the re-

newal of vision which those masters continued to have until the end of their long lives. Another generation, without the vast experience of the older men as a foundation, needed to put forth a special effort of its own. Instead, the Salon d'Automne and its allied exhibitions showed preciosity, the exploiting of nuances, and a tendency towards the decorative arts—that almost sure sign, in modern times, of ill-health. For the decorative arts of the past owe their beauty to the craftsmen, to the artisans, whose pride in their work now finds its true expression in the miracles of our machine-shops, in such modern perfections as the engine, steering-gear and other parts of the automobile which arrest our admiration as we pass the shop-windows where they are displayed. These admirable things grow "from the ground up," and the painter of pictures who tries to approach them from the top—from an aspect of beauty which is so different from that of his own work—is ridiculous in his failure to comprehend the source of excellence in the applied arts, and accuses himself of impotence in the practice of his own. Impotence was precisely what threatened, twenty-odd years ago, when the splendor achieved by the artists of the preceding decades lulled the second group of Post-Impressionists into a surcease from creating. An exception must be made in the case of Maurice Prendergast who, in other respects, is to be placed with this group. He returned to America when his period of study in France had made him aware of the problems offered by the Impressionists and Cézanne; and the isolation in which he worked out his exquisite color and fresh, personal design is perhaps what gives his pictures the vigor which often makes us prefer them to more accomplished per-

formances by some of the Frenchmen of the time, whose superficial likeness to the masters cloaks their underlying weakness.

Dislike for such a softening of modern art gave the final spur to the men who came to be called *les Fauves*. For them there should be no compromise, and they launched out on their emphatic statement of the significance of things as they saw them, stripping their work of every unessential. Rouault, in his first period, had painted dramatic compositions of much beauty, but clogged in their effect by the mass of realistic detail which he had thought it necessary to include. He used his new freedom to stress those elements which he felt to be the expressive ones. It is the caricaturist's method, but he applied it not merely to the story-telling features of the picture, but to the form and color as well. Violence was the natural reaction of the whole group to the flabbiness around them; and with Rouault, feeding on the strong meat of his law-courts, his religious dramas and his brothels, it was a natural, necessary mood, whose genuineness is vouched for by the superb tonality and the unfaltering beat of line in his pictures. He continues with very much the same point of view from year to year, but with the increasing power and dignity of his expression, the best of living artists and a widening section of the public have become convinced that his likeness to the old Gothic men, and to Daumier and Guys, is no superficial matter, but one inherent in the character of the man.

When *les Fauves* were forming, Derain was barely twenty years old and scarcely recognizable as the artist we know to-day. Yet when he observed how design was used by Gauguin as a means of escape from mere

reproduction of his romantic subjects, when he proved by a return to solid color that van Gogh did not achieve his immense luminosity by his broken brushwork but by observing the laws of light, he was for the first time falling into the rôle of leadership which he continues to hold. Already the prime reason for his authority lay in the beauty which his grave, logical but imaginative mind has always given to his art. The severe use of line in some of his early engravings strongly suggests a likeness of mentality between him and Dürer, who is recalled again by some of the recent work of Derain, of which I shall speak in a later chapter. At least a mention must be made of the charming art of Dufy, the sturdy Cézannesque painting of Friesz, and the great talent of Braque, which was to find its real development through Cubism.

It was Matisse who carried farthest the effort of his group. He not only heightened effects as Rouault did, but made daring transpositions of color and form. The colorists just before him had shown that each tone exists through its relation with those around it; Matisse, by forcing a pale pink into full crimson or a gray blue into full cobalt, would raise all the rest of the scale accordingly, suppressing intermediates but keeping the equilibrium of the color. It was as if he were observing it under a magnifying glass, not in order to look farther into the component parts of it which his predecessors had analyzed so carefully, but to establish on the firmest base the harmonic relation of the hues. In later years, with this preparation well behind him, he has been able to reverse the process and give us pictures painted with little more than black and white but seeming to contain the full range of the palette. In his use of line and mass also, his simplifi-

cations were far more than a means of escaping the
trap constantly set for us by our modern sureness as
copyists of appearances; they served, above all, to per-
mit his investigating the effect of an added weight or
emphasis on one volume and the means of compensat-
ing it by the thrust and pressure of another volume.

When one has become sensitive to the fineness of
three-dimensional design which Matisse, and Derain,
influenced by the figure-pieces of Corot, attained ten or
fifteen years ago, one has, in judging the construction
of pictures, a criterion which will explain the failure
of many a work to maintain evenly the impression of
beauty which it first produced. Pissarro's fine senti-
ment for nature must depend for its expression on his
clear, harmonious color and his graceful silhouettes:
Renoir, with his deeper classicism, balances his picture
in depth as well as on its surface. He does so by in-
stinct and by practice, but other artists have the right to
demand a picture "with reasons in it," as Falstaff said.
Leonardo, for example, was searching for reasons all
his lifetime, and so it was natural that, in this period of
consciousness, Matisse should make especial study of
the great Florentine. This study is evident in the pic-
ture, "La Toilette," where the seated figure is simply
Leonardo's "Bacchus," in the Louvre, painted in a new
key but held together as a living æsthetic organism by
the same play of line and mass. Similarly, if for dif-
ferent reasons, Manet had helped himself to a whole
group from a well-known Raphael for his "Déjeûner
sur l'Herbe," as the world failed to notice for over
forty years—during which time Bouguereau's resem-
blance to Raphael was widely advertised, until every-
body saw that it was false. We know the moderns as
great when they give us the joy that we get from fine

ancient works, but these, in turn, are partly explained to us by the works of our time. To enjoy the marvellous bronze horse lately added to the Greek collections at the Metropolitan Museum of New York, shall we best prepare ourselves for its beauty by a preliminary study of St. Gaudens' horse in the Sherman monument, a work of almost unredeemed literalness, devoid of any structure save that taught in the anatomy-class? Or, taking a step in the matter of subject, in the material employed, and an immeasurably longer step in the matter of the conception, shall we not find ourselves quite in the line of intention of the Greek sculpture when we come to it from a portrait by Matisse, say that most beautiful one of Mme. Matisse, dating from 1913? The glide and stop of the lines, the interplay between the hollows and the projections, the whole sense of proportion and harmony in the two works, is governed by the same sense of fitness; in both cases a mind has transmuted the feeling derived from a contact with nature into the new entity of the work of art.

CUBISM

Has ever a catchy jingle of words wrought more havoc in the minds of the unthinking than that couplet of Pope's which makes up the complete system of æsthetics of so many people?

Art is but nature to advantage dressed,
What oft was thought but ne'er so well expressed.

Only by saying that criticism of an analytical kind is a thing of recent times can we explain the prosperity of that parcel of half-truths, in which "what was thought" and "nature" stand for the same thing, and "to advantage dressed" may stand for anything. Dean Swift unintentionally points out the looseness of idea in the lines by giving us his still more succinct definition of style: "Proper words in proper places." Does anyone to-day so much as imagine he knows which are the proper words when he sits down to write? or having written, can he hope for the agreement of more than a tiny minority of mankind if he esteems himself so fortunate as to have found these proper words and their places? Such philosophy as that contained in the two eighteenth century quotations I have given could be afforded by the world in an epoch when art proceeded in easy harmony with the desires of a public able to follow the slow evolution of new forms. The antagonism between artist and public throughout the modern period, and the repeated contact at the Museum with unfamiliar races and schools were needed to set men thinking about the reasons underly-

ing the impressiveness of the work of art. If a medi-
æval painting, say a Cimabue, attains its awesome
grandeur while its creator is unaware of a single one of
the scientific processes through which our century rep-
resented nature with such completeness (and with such
banal ugliness in the vast majority of cases), then
art is *not* the nature which is to be tricked out in
advantageous dress.

From the moment when Ingres went back (or for-
ward) to the Primitives from a school more fully
equipped than theirs with the processes of realism, the
modern period has been one of unremitting search for
the truth about the relationship between nature and
art. This truth is embodied in all the great works of
the past, and perhaps we love a Sienese madonna bet-
ter because her painter is so completely under the spell
of his act of faith; probably a portrait by Rubens is
only the more superb because it appears to exist for
no other purpose than to tell how ravishing were the
eyes, the lips and the bosom of Isabella Brandt or
Helena Fourment. A later age will see that a beauti-
ful subject does not in itself make a beautiful picture,
and it will not be satisfied with the vague statement that
the ideas emitted concerning the subject are what count.
Such a phrase applies as well to a poem as to a picture;
but the two things have separate laws. Even if the
essence of the picture remain as mysterious as life it-
self, we have at least made progress when we recognize
that there is some vital force in art which is not in the
outer world it portrays; and here the question arises
of the means by which the force is transmitted. In-
numerable men had praised the sense of form evinced
by the early Italians and the sense of color which
makes the opulence of Rubens; but not until the

twentieth century did painters consciously take the step, with Cubism, of accepting form and color as the bridge which carries us from the chaos of the world of appearances to the order brought out of it by the mind.

The artists knew that the need of their time was a solution of the conflict between the claims of representation and the necessity of the æsthetic qualities which had always furnished their law; a necessity to which other men were becoming less and less sensitive because of their interest in the scientific realism that they could connect with the material achievement of the time. It was not difficult to demonstrate the scientific rightness of the Impressionists' painting of light, however strange their pictures seemed at first; and the thousands of utterly talentless Impressionistic painters who are to-day profiting by the vogue of Monet and Sisley are proof that only a few persons, after all, appreciate the great men of that school for their art. What has been popularized is their vision of nature, their formula for light and color—a thing referable to the same logic as governs our ideas of the spectroscope, for example. Considering the ideas of most artists as well as laymen in the late nineteenth century, the confusion is comprehensible enough, for such was the cult of material appearances that these were generally regarded as the only possible reason for the presence of forms and colors in a picture. Though the idea is losing ground, it is still that of a majority. Post-Impressionism offered a better conception of art, indeed any work, ancient or modern, does so if one penetrates to its significance. But with the retaining of any semblance of the imitative, some chance for confusion between art and nature remained. In a Cubistic picture there is no such chance: one can judge the work only as good

art or bad. There is a reference to the thing seen,—certain phases of it are given (and no work can give them all, since no man is impressed by them all), but the structure of color and form built from these phases of the object is now to be referred to no law of the material sciences—anatomy, perspective, luminosity, etc.; the work is to be considered as idea, as art.

Had Cubism rendered us no other service, it would be important enough as affording a new insight into the qualities of the picture. If there ever was an excuse for an art-critic to think of the proportions of a Mantegna figure (say those elongated ones in his masterpiece of the "Crucifixion") in comparison with a living model, there is no such excuse to-day, nor is there any for naturalistic explanations of the color in a Giorgione or a Renoir: close to the facts of nature or far from them as we may consider these pictures, according to our habit and our period, we shall henceforward have to set our value on them not as attempts to produce the illusion of seeing their subjects within a frame, but as offering us a new reality: that of the master's idea of life. The arts which demand the severest application of this criterion are evidently those which follow the appearances of nature most closely, like the Greeks of the Phidian period or those of the fourth century. No competent person has ever confused the Hermes of Praxiteles with the naturalistic sculpture of the modern academies; but in seeking the reason for the unbridgeable distance between the two, I believe no explanation will avail so completely as that of the difference between æsthetic structure and reproductive transcription.

As long as we persist in the habit of judging pictures by their likeness to nature (that is, their likeness to a

given convention of nature, one determined by a previous experience with pictures), so long do we miss their significance. Watch the dull expression on the faces of the tourists who dutifully file past the old pictures in the Louvre or the Uffizi, accepting the statement of the guide-book that these are the world's masterpieces, but privately maintaining that "they aren't natural." One would agree, if one were not giving aid and comfort to the opinion that there is greater naturalness in Inness and Sargent—not to mention the baser imagery which has formed the modern idea of what the world looks like. The wise Orient attained peace ages ago as regards the relationship of art and nature in painting; and the masters of the Japanese print, for example, eschewing any attempt to create an illusion of sight, went on with tranquil surety until the West forced its troubled art upon them, an art more glorious in its disquietude, we may be permitted to believe, however, than theirs in its serenity. Doubtless the appreciation of Oriental art in the nineteenth century hastened us in becoming conscious of our problem; doubtless the African art which aroused the enthusiasm of certain painters and sculptors in the first years of the twentieth century offered forms which were of great aid to us, because the negro, with his intensity of emotion and his incredible mastery of wood-carving, translates his religious awe through hard planes which elongate and intersect in a manner suggesting an escape from the tyranny of the visible, against which we were struggling.

At bottom, however, the sources of Cubism are all to be found in European art. Gleizes and Metzinger, in their book, take Courbet as their point of departure; and indeed, with his titanic affirmation of our belief

in the existing world, he is one of the fundamental expounders of European thought. But, as the authors observe immediately afterward, Courbet continues some of the worst of the conventions of sight held at his time. Manet, with all his splendid courage in attacking the blackness which Courbet left in painting, was still not plunging to the essentials of the technical problem that had been raised. It was Cézanne—and to this he owes a part of his immense importance—who saw that the reality we sought was not to be obtained by making an eye-deceiving counterfeit of nature, but that by erecting a structure of form and color whose intervals and harmonies repeat the rhythm that the world establishes in our brain, we produce a "truer" thing than any imitative process can pretend to. Even Cézanne, however, struggles to retain with his structure a representation of the object as seen. His last letters speak of seeing the planes slip out of place, and he is worried about it or, more likely, he is unable to find an explanation for it when writing. Can we doubt that when the old man stood before his canvas he knew that the movement which was coming into his picture was to carry the whole world with it? It is not in a tone of despair that he states that he is the primitive of the way that he has discovered. It is in the tone of triumph with which he thundered at his detractors those words that Elie Faure gathered up during a visit to Aix: "You know well that there is only one painter in Europe—myself!"

The young men—those who count—continue his work. Derain, the haunter of the museums, the student of form who has consulted the Florentines, the Gothic artists and the Greeks, lays aside the brilliant color of his *Fauve* painting in order to investigate the

properties of the contours and planes which Cézanne had endowed with an elasticity like that of steel springs. It is by the varying tension of line, and not by modelling with light and shade, that European art has always raised form to its purest expressiveness: the most unimportant descendant of Giotto gives distinction to form as long as he retains something of the master's sense of contour; whereas modelling with chiaroscuro, among the followers of Rembrandt, sinks to a mere trick of producing illusion, when the spirit of the old seer no longer animates it.

Before starting on the perilous adventure of departing from naturalism farther than ever was done before, painting strengthens its hold on its most efficient tool for dealing with form. Intent on giving to the objects in his pictures a maximum of existence, Derain found that he could force the planes at a centre of vision to greater intensity by weakening, and finally effacing, some passage in the scene to which little or no interest attached. This is the momentous step, similar in direction and in boldness to that of Paolo Uccello when he discovered that to represent the course of parallel lines to the horizon, he must make them approach one another, which, in the mind, they do, and in nature—by their very definition—they never do. For a time, with Uccello's great pupil, Piero della Francesca, the discovery of perspective still served artistic purposes; since then it has been hardened into a scientific formula which few painters have been able to put to expressive use.

But there was such use for the interpenetrating forms that now appear in painting; the world needed them in order to deal with one of its oldest problems, that of representing simultaneously those aspects of a

subject which may be seen only at different moments of time or from different viewpoints. For example, there is a Signorelli, depicting the Magdalen and the disciples finding the tomb of the Savior empty, and also—in the same landscape and without the slightest demarcation between the two scenes—the Magdalen kneeling before the risen Christ. It was such "childish ignorance" of the fact that a person can not be in two places at the same time which earned for Signorelli, and the numberless painters who did this and similar things, the epithet of primitives. After we had come to appreciate the spiritual grandeur of these men and their extraordinary control of the æsthetic qualities, we realized also that the "naïve" conception I have described came from an eternal need within us to retain the continuity of experience—which the Egyptian rendered by the seeming infinite of his form, which a Gothic cathedral offers in the unity running from the great structural lines through to the tiniest detail, and which Rembrandt gives when he makes his light and shadow only merging aspects of the existence of the object in space.

At this point appears the rôle of the "French Rembrandt," as Odilon Redon has so charmingly been called by certain Dutch writers. All the younger artists had studied him, and while some had carried into their work the exotic color of his painting, Picasso—who marks the next step in the central evolution of our time—takes the older master at his word when he says that the plane of the picture is not in the outer world of appearances but in the mind of the artist. An idea or an image never has reality (as distinguished from resemblance) until it has been united by the mind with our previous experience. This being so, Sig-

norelli was not so naïve after all when he showed the
same personage twice in the same scene; for, as the
sacred story unrolled before his mind, its phases were
not separate pictures such as we get when we stop the
film of a cinematograph: the essence of the subject
was in the totality of its images, which he rendered
according to the convention of his time. In our time,
the convention (referred to as "nature," following our
inveterate habit) required the selection of a single
standpoint and a single vanishing-point, as if we were
seeing the subject with the photographer's head-rest
gently keeping us from turning away to get a side or
rear view of the scene.

Pablo Picasso and Georges Braque decided at about
the same moment that they had had their heads held
in the one position long enough. Our knowledge of
objects depends on seeing them from different sides.
Braque and Picasso paint them so; the recombination
of the planes according to their importance in our in-
terest, which I mentioned before, giving the means for
relating, one with another, the phases of sight retained
by memory, and also the empty spaces separating them.
Considering therefore the derivation from the object
of the elements for the Cubistic picture, and consider-
ing it as a new statement of the existence of things, one
sees how Gleizes and Metzinger could claim descent
from Courbet for the painting of their group, even
as the laws of design regulating the organization of the
pictorial elements are drawn from Cézanne. Once
the new convention has lost its look of queerness, we
see that its two factors are those of all art—reality (the
existence of things before the mind) and æsthetic right-
ness. "There is nothing outside of the classics," as
Renoir once said in a conversation. "To please a

pupil, and were he a prince, a musician could not add another note to the scale; he must always return to the first, an octave higher or lower. In art, it is the same thing. Only, one must know how to recognize the classic, which looks different at different times. Poussin was a classic, but *le père* Corot was a classic too." Yesterday it was Renoir himself, a noble and joyous classic; and to-day (I am aware that this is mere assertion, but where is there proof in matters of art— unless we have time to await the verdict of posterity, and can accept that as proof?¹), the classic line has been carried on by these men who have found the Cubistic formula for expressing the relation of the thing as seen to the thing as known.

It is this which differentiates Picasso and Braque, and those who join them in their efforts, from decorators, men evolving designs to apply to textiles, for instance. The decorator's pattern has its value, but it robs the things of the world of their significance; and the things of the world are too wonderful to be used in such fashion in the discussion of them which it is the painter's business to give us. He may accept as little or as much of appearances as he pleases, he may keep his statement within the few essentials set down by a Byzantine painter or extend it to the completeness of a Velasquez. But there are limits of representation beyond which he never passes. As Kant showed that we never can know the thing-in-itself, but only the thing as it is affected by time and space, so the painter never reaches that abstraction we speak of as nature, but is enclosed within the boundaries of his perception.

What is essential to us is that his work render the things *he* has perceived, that it be free from mere repetition of the findings of other men. In a Cubistic pic-

ture, when objects appear and disappear as images do in moving before the mind, an instant of sharply outlined detail being succeeded by a dissipation of the form—the seeming emptiness being filled with other forms, which in turn become distinct,—the painter is setting down for us a record of experience. Any object will serve him as the starting-point of the microcosm within the four walls of the picture-frame: now it is the curious outlines of a violin which release the current of images, now it is a human being, now bottles and newspapers on a table. In the earlier years of Cubism there will still be flashes of direct reference to things, or parts of things, standing out in the starkest relief. And there is still a sense of the picture's being based on the seen world when, for a time, the painters succeed in banishing every recognizable object. "Isn't that just what must happen in the minds of the insane?" asks some one. No, that can not be right. The world has never gone to school to the insane, but it has gone to school to the Cubists. Even some of the older artists have accepted a partial influence from them; as for the younger generation, it counts by thousands the men who have worked in the Cubistic manner or with the forms derived from it. When men are ready to go beyond the severe logic of the school and adopt a naturalistic convention again, they find their vision affected by the painting of the Cubists at least as much as by that of the great schools of the nineteenth century. And so one has the conviction, as with the arts of the earlier modern period, that here again we are listening to "real voices and not to echoes."

When a movement in art has attained its fullest extension, the tide of ideas turns in a different direction.

Thus after the intellect and style of the eighteenth
century, after the bloody crisis of the Revolution, the
world received eagerly the new ideas offered by the
English poets and landscape-painters. And so there
is justification for the words of Sir C. J. Holmes when
he called Constable "the first of the moderns." But
neither Constable nor the men of Barbizon, whom he
influenced, make us conscious of the full implication
of the Romantic idea; it was Delacroix who raised the
Romantic movement to a point of such intensity that
we can see that we are in a new period. Let us recall
once more Corot's illuminating and exact definition:
"Delacroix is an eagle. I am only a skylark." The
prestige of the creator of the noble decorations in the
church of St. Sulpice rests on the fact that he did not
simply renew our classic heritage, as Ingres did, or
give us a vision of nature, like that of the landscapists,
but that he fuses æsthetics and vision into an expression
of the whole spirit of the time and so gives his work
a symbolic character.

I believe that an understanding of the genesis of
the thought of the early nineteenth century furnishes
the key to the thought of our own time, different as
it is. The immense accomplishment of the years be-
tween 1850 and 1900, let us say, already seems far
from us. It has that kind of aureole that bygone
things have and is almost as difficult to use as the arts
of the Cinquecento; perhaps indeed the young painter
is safer if he addresses himself to Leonardo or to
Titian, not merely as greater masters, but as being less
apt than Manet or Renoir to offer the illusion that he
is continuing their work. For those admirable artists,
whom we still call modern, belong to a period whose
ideas have been expressed so definitively that we, in

our day, cannot see things with their eyes, any more than Ingres or Delacroix could see with the eyes of the eighteenth century. The parallel between our conditions and those of a hundred years ago lies in the need to unite the classic, æsthetic principles (seen today in the work of Cézanne, Seurat and Matisse), with the vision of our time, especially that vision of the inner world first predicated by Redon and carried by the Cubists to a point where it breaks entirely with the formula for appearances which was characteristic of nineteenth-century realism. The formula had been modified by the successors of Impressionism; but to the new generation, conscious of the fundamental difference between its vision and that of its fathers and grandfathers, mere modification would have been compromise, the poorest thing in art. The adjustments of plane and color used by Cézanne with such immense effect become meaningless deformation in the hands of most of his followers, whom one counts by the thousand in the modern exhibitions. The high, spiritual expressiveness of Matisse is travestied by the idiotically bad drawing of men who have neither his emotional response to life nor his tremendous ability to convert his sensation into design and color. It was because he had too much difficulty in getting pupils to follow his methods, instead of imitating his effects, that Matisse closed his short-lived and soon overcrowded school. The bad "modern" picture is just as futile, and to-day, at least, a little more objectionable than the bad "old-fashioned" pictures which would lead us to believe that the attitude of a Théodore Rousseau towards nature was maudlin sentimentality; or that what distinguished the artists before Raphael was their accumulation of detail; or that the virtues of

Hals and Velasquez can be attained again by a combination of photography and sleight-of-hand.

Taking final leave of all these things which, in the good expression of the French studios, "do not exist," and coming back to the realities of our time, one may safely say that it has not yet found an inclusive, definitive expression, such as Delacroix gave to his time. Cubism might at most represent the point reached by Géricault, a man on fire with the young genius of his generation, but still under the harsh discipline of David, the revolutionist, who carried into his studio the rigors of an intolerant political logic. It is because we are, as Renoir said, in a period of seeking, because the synthesis towards which we were working before 1914 seems only a little ahead, that one must believe that the great modern effort can not have been arrested or even deflected by the war.

I have used the word Cubism in its most widely accepted sense, as denoting the outer appearance of a certain group of paintings and sculptures, and not in the more general sense in which some would apply it to works combining into design the elements of a scene consciously selected by the artist for their expressiveness. Such a definition, good as far as it goes, would not exclude the arts of the past, which, in fusing the content of the mind with what is seen by the eyes, have given us our record of the character and life of the various periods. The life of our own time has its more obvious expression in the size of buildings, the swiftness of vehicles and the quantity of manufactures. But such things, by the very weight they lay upon the imagination, make it seek the more eagerly for an expression dealing with the essentials of our experience, not as they exist as expressed by topography, light,

avoirdupois and the yard-stick, but as we know them
in their assimilation into our thought, and through the
forms and colors which so define them. As the artists
give us their equivalent for this thought, their allusion
to the world of the eyes may be more or less complete
and specific: in this picture sections of objects seen re-
call an impression that seemed especially significant,
in another picture the whole tissue of the work is com-
posed of forms in which the subject that served the
artist as a "springboard"—to use an apt expression of
Gleizes's—has become unrecognizable, in a third work
natural objects are transcribed with the most savage
realism—the grain of a piece of wood, for example,
showing as if under a powerful light. But the objects
are not copied for their own sake, as in the dismally
resembling family portrait, or in order to exhibit the
painter's skill, as in the pictures where a visiting card
or a pair of spectacles "look real." In these Cubistic
works the sharp visibility of the objects comes like a
concrete fact or a date in a discussion of ideas, and is
no more imitative than they.

"Granting that all this is in the intention of the art-
ist," some one may ask, "how can any uninitiated
mortal be expected to know it, when you admit that in
some of these works all likeness to recognizable ob-
jects has disappeared?"

The intention of the picture may be reached by one
who approaches it as he approaches the pictures in
the great museums. How much do "subjects" inter-
est us there? What we ask to "recognize" is the spirit-
ual value of the artists who did the work; something
which is not expressed through resemblance to nature
but through æsthetic quality. Leaving out the pic-
tures impeccable from the standpoint of representation

but worthless as art, and taking two works by masters, we prefer the "Odalisque" of Ingres to the "Olympia" of Manet, not because the former is more like its model, for it is not, but because the pictorial space within its rectangle is more perfectly distinguished from the actual space of the outer world; because the forms filling the space of the "Odalisque" are related according to the laws governing our sense of harmony between solid and void, emphasis and silence, and so give life to that space, and raise the work to a higher plane of creativeness than that of the "Olympia" with its less sustained assimilation of the actual forms and the actual life by which the great realist was at moments too completely fascinated. We are impatient with the stupidity of the visitor to the museum who veils his eyes before the nudity of Rubens' women, or who fails to see that the gracious elegance of the eighteenth century is preserved far more pure, more intense, in a picture of eggs and meat by Chardin than in the portrait of a marquise by La Tour. Before these works whose formula we know so well, we pass beyond a consideration of subject to the mind of the man that gives beauty, not to the nude women, the still-life objects or the marquise, but to a work of art. Cubism, in our age of conscious purpose, has given us works of art which, for anyone who grasps their significance (as thousands of the people have already done), abolish the confusion between the essential and the apparent subject-matter of the picture.

The movement inaugurated by Picasso and Braque was not exhausted by them. Within a short time, many or perhaps most of the strongest men of the younger generation saw its possibilities, and important modifications of direction and increases of expressive-

ness were made by Metzinger, Gleizes, Léger, Villon, de la Fresnaye, Gris and Rivera, who are probably still the men who count most in their school, together with Villon's brothers, Raymond Duchamp-Villon, the sculptor, and Marcel Duchamp, of whom I shall speak at greater length, in order to typify, through them, the best of the later Cubism.

Duchamp-Villon is himself from his first works. They contained, as he said, something of the influence of Rodin which was the starting point of almost every young sculptor of his generation. He was quick to see that the necessary step before him lay in an advance from Rodin's lack of clarity in the structure as a whole; a lack for which the Impressionist had partly compensated by his delight in luminous, sensuous modelling and by the sense of intimate knowledge at which he arrived in fragments of his works. The years which Duchamp-Villon gave to the development of a more truly sculpturesque form may be said to have culminated in his head of Baudelaire, which for grandeur—both in its conception and in the handling of the strong planes through which he built up the volumes—seems by no means unworthy to stand with the masterpieces of the old Gothic artists. Then, under the influence of Cubism, he begins to isolate the planes as the painters had done, to accentuate the directions of form and to make one section overlap another, a bolder departure in the apparently more literal art of sculpture than in painting. It was also a more necessary step, for sculpture was being immobilized by the bird-lime of brainless imitation even more than its sister art. A period of remarkable and, as we still hope, epoch-making work in architecture followed. Duchamp-Villon, however, died in the

war, its greatest victim, and we can not be sure whether others will be able to carry on his architectural achievement. Two points suggest themselves in this connection: that the period had become conscious of its need of an art in which many men could collaborate; and that, considering the geometrical basis of architecture, we may see in this work of Duchamp-Villon the fullest expression of the sense of proportion based on mathematical relationships, which Cubism was working to restore to art, and which Realism and the instinctive artists (Cézanne and Seurat evidently not among them) had almost lost. The last great work of the sculptor had as its basis a running horse whose motion, interpreted in mechanistic terms, suggests not so much the parts of a machine, as our present conception of life and its forces. To find a precedent for this work one must go back to the sphinx, the winged bull and other hybrids of the ancients. Like them it must be seen, not described; for none of these belongs with Expressionistic or Futuristic works, which are literary forms invented in an attempt to eke out an incapacity for plastic art. In looking at Duchamp-Villon's horse, one would do well to forget all the reasons and explanations that I have attempted to give in this chapter. They were well meant, as tentative answers to the questions which perplex so many people to-day when they try to follow the rapid course of modern art. But the only reasons and explanations of art reside in its works; and the test of these works lies in their likeness in essentials to the classics, the things of which we are sure. Not a few of us believe that the monumental work that Duchamp-Villon finished just before his death is of the family of the greatest achievement of nineteenth-century sculpture, Barye's

"Theseus Slaying the Centaur," whose terrific movement and compensating firmness are exemplified again in the work of our contemporary.

Marcel Duchamp's painting is perhaps the purest, perhaps the strongest in his group. The evolution of his two brothers—ten and twelve years older than he —saved time for him by enabling him to pass from the quasi-naturalism of his first works to the Cubistic form more suited to his introspective mind. Experiments with the painting of motion (such as the "Nude Descending a Staircase") carry him on to a complete acceptance of the conception of pictorial space as a thing nonexistent outside the mind; a conception that Redon, whose imagination was always haunted by the idea of space, had hinted at, and that Picasso had realized in freeing his still-life objects and his personages from the death that comes of copying, of trying to arrest a moment of time; for a work of art seizes the life of the moment only to send it speeding on ahead of us, as the classics always are. Did not the Greeks copy? asks some one. Place a cast from a Greek sculpture beside a cast from nature and see the difference—as literally as can be—the difference between life and death! In the last canvases that Duchamp did before addressing himself to other mediums, the forms and colors are pure inventions, or so distantly derived from nature as to count as inventions. Their purpose is still to give body to certain deep ideas, and they attain a profound and original beauty. But this very beauty, in its connection with the medium of painting, seemed to the artist a bond to be broken in the interest of the idea.

For those who had appreciated the absoluteness of invention in a work like the "King and Queen Sur-

rounded by Swift Nudes," the grandeur of the forms seemed a definitive achievement. But to the mind of their creator, always fascinated by the unknown ahead of him, there were steps yet to be taken. The canvas on which he had painted, even though purged of every trace of preciosity, seemed to be cut off from the life of the surrounding world, and so Duchamp worked on glass, covering only part of it and allowing the people and objects in the room to be seen through it—his designs hanging suspended in space. But the very glass for this series of works gave to the pigment a new charm under his skilful hand, and at once the followers of the artist began to exploit this beauty of the material— which Duchamp had adopted in order to orient his work in the direction of pure idea. Perhaps a new generation will have to come before the true effect of his research will be seen, in the work of men who feel the current of modern life strongly enough to render it in such epitomized fashion once more. But this one expression of thought cannot exist in entire isolation: like that of Redon and of Seurat—artists whom Duchamp especially admires—it may be long in finding a fitting response, but it is too deep a thing to be other than one of the symbols of our age.

Meanwhile, the multiplication of systems for producing art—Futurism, Vorticism, Synchromism, Expressionism, etc.—among men who mistake a programme for a performance, wearies the world until some one replies with "Dada" (baby-talk), and the whole tribe are invited to wipe off their slates, or turn to the photographer's clean representation of the objective. Indeed, from the admirable daguerreotypes of the old days to the photographs made by certain imaginative craftsmen in our time, and to certain films

of the cinematograph, the camera has been giving us a production of great value. It is not to be estimated by the resemblance of the photograph to a painting, any more than one prizes a painting for its likeness to a photograph. The two ideals exclude each other; yet our delight in perfect accomplishment has caused many a modern man to wish that the older arts might more often succeed in their field as completely as the photographer does in his. Attempts at uniting the two dissimilar processes have been made, and some people have even despaired of the possibility of painting in our time, when the camera has dominated men's vision to so great an extent and increased confusion as to the significance of the Museum. But the world has not had enough time to appreciate the value and the limitations of the instrument. To those who see that its definitive achievement lies with the world of external appearances, it affords a new conviction that the classics are a reflection of thought. In all periods there have been counsels of despair, at times uttered by strong men—who have later gone on with their work, at other times by men unfitted for their work. (Could photography drive the thousands of ill-equipped painters into other pursuits, it would accomplish something too vast even to hope for.) But the outcry of men too weak to stand the impact of the idea is not even heard in the quiet of those studios where the artists of our time go on with their work. Whether they continue with a Cubistic formula or whether they turn to another convention, there is never any turning back for Picasso, Braque and Villon, among those whose later painting must still be discussed. All go forward; and in the direction they had previously set for themselves. Only the future can decide how much

Cubism is to be thought of as part of the central current of art, how much as one of the eddies which result from every great movement. That it is a great force, negating the false things of our time and strengthening much that is best in it, I believe to be beyond doubt —as also that certain of its works will endure as vital and beautiful things.

TO-DAY

Two admirable artists whom I have had no occasion to discuss in previous chapters, Constantin Brancusi, the Rumanian sculptor, and Henri Rousseau, surnamed *le Douanier* because of his years in the customs-service, stand outside all groups of the modern men but are their very good neighbors. The work of Rousseau, a man of the people, with no more preparation than that of the village sign-painter (which is not, after all, the worst in the world), has a decorative quality of a greater fineness than that of Gauguin. Brancusi not only immersed himself in the spirit of Paris, but is nearer its art on the technical and theoretical sides than he at first appears to be.

We understand how much a man of the modern period Henri Rousseau is when we consider the esteem in which he is held by the best artists of to-day. Imagine him appearing in the eighteenth century, or the seventeenth; periods when painting was a craft, and when general opinion designated those individuals who were fitted to practise it as an art! One can hardly conceive a master of that time delighting in the primitive and yet beautiful character of a picture like "le Poète et sa Muse," about which the poet himself, Guillaume Apollinaire, not to be outdone in ingenuousness, wrote that it must have been like him because the painter took the measurements of all the parts of his face. Yet it was just this meticulous attention to every tiny fact that won for Rousseau the admiration of men who had the learning of the schools at their

finger-tips, and who might have dashed off things that would "knock the walls" of the Salon, had they not seen better use for their ability. But far more important than the astonishing design of Rousseau's jungle pictures, or the flower-like "quality" of his paint, was the intensity with which he looked at the people and the things about him, and so gave to a generation surfeited with thought, a contemporary example of that freshness of vision which we love in a Foucquet or a Breughel, and which has misled numberless people regarding the profundity of their skill and power. While few would claim that Rousseau will be ranked by the future as the equal of these two men, there is something of their quality in him, and his art helped to renew the attraction of naturalistic painting when artists were ready for it.

Perhaps there is no art more difficult to describe than that of Brancusi; at least in those phases of it that have to do with his incomparable workmanship, his intimate knowledge of substances, wood, stone, marble or brass. When one of his sculptures is reproduced—say, a marble that is cast in bronze—he works over it with chisel, polishers and acid until the second piece is quite as much an original as the first. For years he will keep under his eyes some beam of weathered oak that he has saved from a demolished house, or some water-worn stone that he has picked up by the river, until, having lived with them, he feels able to touch them without spoiling their natural beauty, which must be embodied in his work. Perhaps in telling of Brancusi's feeling for his materials I am, in the mind of some reader, convicting the artist of a type of mysticism which seems out of place in so "definite" an art as sculpture. But before such a

judgment is passed, I would ask the reader to think of the Egyptian's handling of his basalt; the Negro's knowledge of his wood; the different ways in which a Chinese works his stone, bronze and ivory; or the Greek's use of marble, so infinitely sensitive in its largeness that a mere broken fragment (the architectural bit from the Erechtheum in the Metropolitan Museum, for example), may be said, without exaggeration or sentimentality, to appear warm, and to beat, under the light, like a pulse. After looking at these classic works, I believe one will see a corresponding quality in Brancusi's sculpture; and one's respect for our period will be deepened. If the qualities of surface that I have described were not the reverberation of the inner life of the work, they would, of course, be mere preciosity; as false as certain American imitations of Florentine art, or as certain confused misunderstandings—also American—of the archaic Greeks. But they are merely an index to the idea of the sculpture as a whole, now gentle as in the "Sleeping Muse"; now huge in characterization and in sweep of curving planes, as in the portrait of "Mlle. Pogany"; now resplendent with the wonder of an Eastern folk-tale, as in the "Golden Bird." Or again, they are equally charged with the idea, but keep the secret of their origins like some carved stone of the Aztecs or the Hindus, or like a pyramid, a sonata, or a Cubistic painting—none of which fails to give its meaning to those who can see past the blank paper offered by the appearances of nature, and read the writing which is art.

When, in my last chapter, I spoke of the present time as exhibiting both the impetuosity of Géricault and the discipline of David, I had in mind the struggle be-

tween the tendency to risk once more the painting of appearances (the mark of that unprecedented degradation shown in the bad art of modern times), and the tendency to hold to the "abstract" material from which the danger of imitating external things is eliminated. Two masters, Matisse and Derain (it is not too soon to give them the title), had indeed never gone far in the direction set by Picasso and Braque. Matisse once used the word "materialistic" to describe the conception of a bad Cubist, who combined his images with as little assimilation of them into vision as the most servile copyist of nature at the Beaux-Arts. So the tool remains a tool; and one method of painting is as good as another, according to which individual uses it. Matisse himself, after the period of *les Fauves* in which he made lithographs with a line a quarter of an inch wide, and when his whole art needed a similarly insistent emphasis—in burning color and intensified form—comes rapidly to etchings of exquisite fineness, and to drawings which, in their air of literalness and in their minuteness of detail, recall Cranach or Clouet. But the purity of design, the calm beauty of color in his later painting are guarantees that the image has passed through the alembic of his mind as truly as did the "sensational" pictures that he did ten or fifteen years ago. They do not, however, guarantee him against charges of painting to please the public, even as the older works were explained as attempts to gain the notoriety which comes of outraging the public. Having survived the earlier accusation he will, I believe, also survive the later one.

Modern art and Paris need trouble as little as Matisse about recent lamentations over their decadence. Even without the war, it is normal, as I have

shown previously, for a certain number of years to pass
without the appearance of a new master or a new tend-
ency: as Marcel Duchamp once remarked. "The
new men are there, but we are not able to recognize
them." It will be time enough to speak of the hegem-
ony of art passing from the French when masters be-
gin to appear in other countries. Picasso came to
Paris when about twenty and Brancusi but little later
in life; so that their art may be said to have appeared
in France and to be largely a product of the French
school which, in frankly accepting ideas from them,
took back less than it had given. The other foreigners
in Paris to-day, meritorious as they sometimes are,
have nothing of a creative character to offer; the same
may be said of the painters and sculptors residing in
their own countries, with the exception of Diego
Rivera. For years a strong figure in Paris, where he
formed his art, he is now producing some most ad-
mirable mural decorations in his native Mexico.

Doubtless many people who accept my strictures as
applying to the United States, England, and Germany,
despite the immense vigor and intelligence of the Ger-
man artists, would consider that a special place should
be made for the Russians, either as a whole school or
for certain individuals. I believe a closer acquaint-
ance with modern Russian work will show that, as a
rule, it only coarsens the fiber of the art which Paris
gave us a decade or two ago, either bawling its har-
monies out of tune or sickening them with the per-
fumery of an ill-assimilated orientalism. A few Rus-
sians do, indeed, rise above this level, but I believe not
one reaches the plane of mastery, such as the novelists
of the country occupy. In the less ambitious field of
the humorists and in certain remaining forms of

peasant handicraft, one finds the healthier expression of Russian art.

To write an inclusive history of modern art, omissions from my pages far more important than that of the Russians would have to be filled in. Men too big to be thought of as minor figures in the period must occur to every reader, and if I have not mentioned painters like Chassériau and Toulouse-Lautrec, to name but two of the most admirable among many whose art will live, the reason is that their tendencies are more completely expressed by others. It would be a poor priggishness, however, to restrict one's interest to the men who may be called the masters; among the works even of those who will never be given the title there is a wealth of production that is of permanent value, that is genuine and lovable.

The paucity of significant examples of the applied arts in modern times and the virtual absence of architecture has made me leave them almost out of the discussion. This loss is not altogether compensated for by the superb workmanship and the design of such things as the automobile and the aeroplane; nor is the steel and concrete construction of our big buildings and our bridges on a plane with architecture as it was practised in the past. However much the two modern forms are superior to the "art-craft" productions of certain studios, and to our "tasty" imitations of the various architectural styles of other eras, there is a difference between the industrial artist or the bridge-builder of to-day and the men of the old time whom they replace as nearly as they can. For these modern works are part of what we may call the unconscious art of our period, things which neither their producers nor their public usually think of as art; whereas, even if

the mediæval armorer or the Renaissance ceramist did
not think of his work as something which like painting
and sculpture would one day be placed in the mu-
seums, still the old craftsmen were very near in spirit
to the greater arts, at which they often arrived them-
selves; and of course a mere glance at the cathedral of
Chartres or the Ponte Santa Trinità in Florence tells us
how fully its architect was aware that such a work was
to have an aspect of beauty as well as of use. Yet our
articles of utility, in their increasingly modern char-
acter, and our building, with its growing frankness and
knowledge of its own qualities, offer every reason for
confidence that we are on the threshold of a genuine
and important style in these arts.

But it is on our painting and sculpture that we must
depend for an expression of our time; and this expres-
sion is so intimately our own that no one, I believe,
can yet estimate its value in comparison with that of
other periods. Renouncing such an attempt, I will
speak of the present work of certain men still in their
forties who, with Matisse, seem to me to be doing the
most significant pictures of to-day. In this group
Jacques Villon has a special interest because it is he,
I believe, who, more than anyone else, continues to ex-
press the indomitable spirit of adventure, the beautiful
youth of the world's mind in the days before the war.
When he got back to the studio which he had not en-
tered since the August of 1914, it was to take up his
painting at the point where it had been interrupted,
more than four years before, and to push it forward in
the Cubistic direction it was then taking. For him, it
was not enough to rid himself of the tyranny of the
object; he painted pictures in which the suggestion of
light and of space was eliminated, as they were not

in the earlier Cubism. A negative process? No; for
the design he attained had a quality of absoluteness un-
equalled by even the fine things he had done in former
years; and the color for which he always showed a dis-
tinguished aptitude, is of a purity and beauty that soon
carry one past the old difficulty about the subjects of
his works. There is nothing about his art to connect it
with the color-organ (if that instrument may be said
to have produced valid results up to now), neither is
his painting abstract in the sense intended by the æs-
thetes, who dream of abandoning not only the appear-
ances of nature but its significance. To use once more
an art of the past as an analogy, I would recall the
work of the old enamellers, and of the glass-painters of
the cathedrals, whose flat color, unmodulated over con-
siderable surfaces, expressed the fervor of their age
quite as well as those arts of their contemporaries
wherein a well-defined phase of representation exists.
Villon's works, however, are not designs for enamel or
glass; they are paintings, created with regard for the
special qualities of their medium, proceeding from the
pictorial effort which immediately preceded them, and
leading up naturally and logically to the "objective"
convention in which he is again working.

Painting could scarcely have gone farther in the
direction of the subjective; and indeed, for Picasso, the
moment arrived some years ago when he felt that the
most interesting picture he could do would be one in
which his findings as a Cubist would be included in
works like the figure-pieces of his pre-Cubistic period.
But how different they are, these new Picassos! The
earlier restless excitement of his scenes of poverty and
Bohemia, splendid as it was in the swift drawing that
conveyed it, has given way to the calm and measure of

an art whose classical basis is found alike in the works
in the museums which the artist has loved, and in his
investigation of pictorial structure during the years
when that which is now a head, an arm, a tree or a
sheet of water was translated by forms and their inter-
spaces and their penetration of one another. Yet if
the present work of Picasso offers no difficulty as to
the people or objects it represents, let no one think it
a whit less mysterious than the most "abstract" of his
painting between 1910 and 1920—a type of work
which he does not renounce, either as to its value or
as to its production. Quite conceivably, the student
of a later generation will find the Cubistic works more
clear in their intention, more "legible" as the French
say, than the pictures in which a naturalistic exterior
veils (but only half conceals) the æsthetic structure
within.

A development similar to Picasso's has taken place
in the painting of a number of men. With Rivera, it
is exemplified in those frescoes in Mexico which I
mentioned earlier. They are of great importance as
being the first works of large scale to be done by a man
who has run the full gamut of the modern evolution.
While realistic in their noting of appearances, and in-
deed very accurate in their sympathetic observation of
the life of the people they represent, they are as far as
the poles from the work of the mere illustrator. With
a full measure of that passionate pride in the things of
his country which is typical of the Mexican, Rivera
knows that the representation of a subject does not in
itself carry with it the expression of an artist's idea
of the significance of that subject. Accordingly, the
lines and colors of his frescoes are brought to a unity
even severer, more organic, than that which he could

attain in the previous stages of his evolution, when he was working with purely abstract form. "If I was a Cubist then," he has said, "I am ten times as much a Cubist to-day." And while I believe that some such term as Post-Cubistic is needed for the present conception of his painting, it is clearly a derivative of the earlier forms of Cubism.

Among the main initiators of that movement, Braque may be the one whose connection with it will yet appear as the most intimate of all. Picasso, with his early tendency toward the illustrative, toward over-emphasizing the aspect of sentiment and drama in the characters he created, plunged into the work which offered relief from this temptation and found in it a discipline to which he owes some of the finest examples of his art. For Braque, coming from the Post-Impressionist school which had already given him the habit of revaluing for his picture the forms and colors of nature, there was less of effort, even if the same necessity for the evolution to a Cubistic style, and so he continued with it longer than most of the other artists. The peculiarly French quality of his liking for order and logic made the use of the geometrical figures appropriate to his taste, and no one employed the restrained color of the school with more exquisite effect in certain canvases, or with more of dignity and largeness in others. As Braque moves on to a more naturalistic formula to-day (after a moment when one feared that he would permit his work to become a mere repetition of itself—even if a charming one), we see how his mind has been enriched by his experience; the new style which he is evolving at present could not have come into existence without his years of investi-

gating the expressiveness of form and color in the Cubistic manner.

The war has shaken Derain as little as it has the men just mentioned. Perhaps, even, the long days and years when he was away from his painting gave the meditative mind of the artist a turn toward his present conception of the picture; a graver and nobler conception than any he had attained before. Always unafraid in his use of the knowledge offered by the past, his preoccupation with the geometrical quality in Gothic sculpture, and with Cézanne's use of angles and planes in painting, has evolved toward a subtler synthesis than he could handle ten years ago. He has reached it under the guidance of Corot's draftsmanship, and of the magical ordering of spheroidal form which gives us our secure sense of reality in the presence of that love of the world which Renoir told of in his imagery, a thousand times repeated, and yet always and inexhaustibly new. As with Corot and with Renoir, as with Ingres whose name is so often invoked by the later men, there is a prodigious life within the classical forms which all have studied and made their own. Derain, of all our contemporaries the most exacting toward himself as regards his analysis of the art of the Museum, goes to the world of men and women for inspiration and tells of this world with intense and yet serene enjoyment. We are still living in a time when there are masters. One feels it again on returning to one of those creations of new and impeccable form which Duchamp has given us. One feels it before the late pictures of Matisse, no less creative, for all the subtlety with which he now transmutes the appearances of the world of the eyes.

Thus the work of the artists goes on "according to the days, according to the season," as Redon said. "Nothing comes from nothing," another of his sayings ran: each painting or sculpture is both effect and cause. We divide off a certain period and call it modern so that we may, for the moment, study it for itself; but these men whom we have been observing can not really be detached from the past, and they—with it—have in their hands the making of the future.

NOTES ON THE ILLUSTRATIONS

A. L. BARYE (1796–1875). Theseus Slaying the Centaur (*Frontispiece*).

While, in general, photographs give a more accurate idea of works of art than representations made by hand, the case of the Barye monument in Paris presents an exception. It is surrounded by trees planted so nearby that in order to photograph the great figures at the top of the shaft, a camera would have to be pointed upward at such an angle as to give a false impression of them. It was to overcome this difficulty that I resorted to the etching-plate, an original print from which forms the frontispiece of this book.

The choice of the subject, as representing the art of Barye, imposed itself for the reason that in this example alone one sees the artist as the giant that he is. Other works in full size are either too inaccessible or of lesser importance. The version of the Theseus selected by the Franco-American committee which erected the monument on the Ile St. Louis is Barye's second and final rendering of the subject. Its lines and surfaces are far more completely organized than those of the earlier version, which seems, by comparison, a naturalistic study. While it is not necessary to consider Barye in the works having human subjects in order to see that he is a sculptor and not merely an "animalist," as so many still think him, it is difficult for most people to realize the full magnificence of his art from the small bronzes through which he is usually known.

1. LOUIS DAVID (1748–1825). The Family of Michel Gérard.

In the portrait of David's fellow member of the Revolutionary Convention, Michel Gérard and his family, one

has the full measure of the art which went into the paint-
er's rendering of themes from the history of antiquity, like
the *Oath of the Horatii,* and also into scenes of his own
period like the *Sacre de Napoléon.* The great picture of
Marat in Brussels is the work which most strikingly marks
the contrast of David's art with that of his uncle, Boucher,
the eighteenth century painter, on one hand, and with that
of his pupil, Ingres, the nineteenth century painter, on the
other. In order to let the difference be seen from the
quality of painting alone, irrespective of the tragic sub-
ject of the *Marat,* I have selected the work here repro-
duced.

2. J. A. D. INGRES (1780–1867). Madame Rivière.

Although this picture is to-day regarded as one of the
painter's masterpieces, the critics who wrote of it when first
exhibited treated it with great severity. An idea of the
changes in vision brought about by time and by the repeated
seeing of works of art, is to be obtained from reading the
contemporary criticisms of the great classicist in Lapauze's
work "Ingres, sa Vie et son Œuvre."

3. J. B. C. COROT (1796–1875). The Woman with
 the Pearl.

It is not alone in Corot's earlier manner that one finds
works showing the classical quality of his art which is so
marked in the "Woman with the Pearl," although recent
critics have been giving most attention to the painting of
his youth, and especially to the pictures he produced in
Italy. The influence of his contact there with the masters
of drawing continued, however, quite to the end of Corot's
lifetime and is to be seen in the best of his landscapes as
well as in his figure-pieces.

4. EUGÈNE DELACROIX (1798–1863). Bacchus and
 Ariadne (The Spring).

One of a series of four great decorations dating from

the last years of the master's life. The reproduction gives an idea of the manner in which Delacroix will stand comparison with the great designers of the past. No black and white can suggest the final knowledge of color which is in this work—the warm tones of the flesh, the blue of the sky, and the clear violet of the hill being held together by intermediate colors and forming a unity as complete as that of the lines and masses.

5. HONORÉ DAUMIER (1808–1879). Small sculptural models of heads.

At the Chamber of Deputies, Daumier frequently modelled in wax such studies as these of the politicians whom he would afterward caricature, using these most vivid impressions as his guide. In no works are the master's great qualities of form more evident than in his sculptures, many of which have unhappily been lost.

6. GUSTAVE COURBET (1819–1877). Woman on a Ship.

Among Courbet's masterpieces one could select a landscape or a still-life as well as the figure-piece reproduced here. Indeed the painter is perhaps most of all to be credited with our modern seeing of all objects in nature as alike susceptible of representation by the man of genius. The great nudes of Courbet may suggest most strongly, however, the parallelism of his art with that of the masters of the past.

7. EDOUARD MANET (1832–1883). Berthe Morisot (Le Repos).

A picture of the artist's mature style, still showing the influence of his study of the museums, but already painting with that clarity which drew the young men to him.

8. CLAUDE MONET (1840–). Landscape in
 Norway.

So much of the quality of Impressionistic painting re-
sides in the color, which indeed largely creates the design,
that photographs give only an inadequate idea of the works
of this school. In the picture here reproduced, it may not
be amiss to see an influence from the Japanese painters of
landscape. Monet, like most of the other masters of his
generation, is an admirer of their work.

9. CAMILLE PISSARRO (1830–1903). Garden with
 Flowering Trees.

The early works of Pissarro, as also of Manet, Monet,
Cézanne and Renoir, are based on the painting of Courbet.
Later as in the picture here shown, one finds something of
Corot's lyrical quality. Though Pissarro accepts influence
from various men, his admirable personality permits him
to assimilate all he learns into the art that is so much
his own.

10. P. A. RENOIR (1841–1919). Mother and Child.

It was at the time from which this work dates that Re-
noir was making the great advances with design in the
third dimension which most distinguish his later from his
earlier work—and from the painting of the other mem-
bers of his school (Cézanne excepted). In the grand or-
dering of the rounded masses, something of Raphael's love
of such form seems here to appear again; it is this quality
which has caused Derain and other men of to-day to study
Renoir anew, after the lesson of his color was understood.

11. RENOIR. Nude.

A work of the artist's later years. At the very end of
his life, a new profundity in Renoir's mastery of volume
developed, and permitted the creation of work whose am-
plitude is not attained in even the finest of his earlier
painting.

12. PAUL CÉZANNE (1839–1906). Portrait of M. Chocquet.

The noting of the planes of color represented by the separate brush strokes is not solely for the purpose of gaining luminosity, though this work dates from but little later than the Impressionist period in Cézanne's career. Already, and indeed in still earlier pictures, there is a consideration of the elements thus arrived at as units in a structure of form.

13. CÉZANNE. Mont Sainte Victoire.

A picture of the very last years of the master's lifetime. The "sculpture" that he was working for in the time when Courbet so much influenced him has given way to a conception of painting in which the aspect of nature—recalling that of the great Chinese painters of mountain scenery—is rendered by a succession of almost abstract forms, which give to the younger men their strongest suggestion of the expressiveness of an art built even more directly on such a base.

14. ODILON REDON (1840–1916). Orpheus.

A work to which the artist was particularly attached, and one that must stand with the finest of his production. Again the lack of color prevents the full appreciation of the almost unearthly quality of this art, but its reliance on introspection, on the world of the mind, as compared with the objective research of Redon's contemporaries, is evident.

15. PAUL GAUGUIN (1848–1903). Tahitian Pastorals.

The originality with which Gauguin handles design in his later pictures (of which this is one) gives to his work a charm which one cannot account for by any preceding art of the modern time in Europe. It is not merely a following of the art of the South Sea peoples, however, but the work of a French painter whose deeper instincts were

released by his contact with a primitive race. Such pictures influenced the men at work in the 'nineties to attempt freer types of composition.

16. VINCENT VAN GOGH (1853–1890). Mme. Ginoux (L'Arlésienne).

The blackness of van Gogh's early work has completely disappeared, and the studious, Impressionistic analysis of light during his first months in France has developed into an audacious synthesis of color suited to the intense consideration of the life of his subjects which still absorbs him in his last period.

17. GEORGES SEURAT (1859–1891). The Circus.

The extreme division of the color into its component hues (as represented by the separate flecks of paint), is perhaps less remarkable than the control over the elements of form which the artist shows in this work; its technical perfection only serves to leave him freer for the expression of his keen delight in the spectacle of the world.

18. GEORGES ROUAULT. (1871–). Two Women.

A painting of the time when the *Fauve* group was making its powerful effort toward a more expressive organization of line and color. The artist's admiration for Daumier is apparent, but not less so the force of his own personality.

19. HENRI MATISSE (1869–). Portrait of Mme. Matisse, 1913.

The work referred to in the text; it may be said to mark a climax in Matisse's earlier concentration on those elements of his picture which bring his design to its maximum of purity, and his characterization to its fullest intensity. The succeeding works of the painter enrich his art, while leaving it free—as at the moment of this portrait—from detail unconnected with its æsthetic and expressive content.

20. ANDRÉ DERAIN (1880–). Portrait of Mme. Derain.

The artist's profound sense of the portrait dictates the varying degrees of accentuation in the features and the contours. His control over the relationships of line builds the work into a structure parallel with that of nature but not copied from nature.

21. GEORGES BRAQUE. The Viaduct of Aix-en-Provence.

Working in Cézanne's country, the artist moves toward a more geometrical organization of the forms derived from the landscape than had been attempted before the time when he (and Picasso) evolved these elements,—out of which the Cubistic picture was to be built shortly afterward.

22. MATISSE. Still Life.

The accenting of certain elements of the picture and the gradual effacing of those less necessary to the design had been tried by other men for a few years before Matisse painted this very large and complete work. Its great impressiveness, however, both in the matter of its æsthetic qualities and its clear statement of idea, makes the canvas an especially valuable example of the evolution to an art based on form as it exists before the mind.

23. ALBERT GLEIZES. Landscape.

The procedure just observed in the picture by Matisse is here carried further by Gleizes. The trees bridge, sky, etc., are noted directly from nature but are immediately given a new spacing and accent in the design.

24. JEAN METZINGER. Still Life.

The logical mind of the artist (who had served a severe apprenticeship in the Neo-Impressionist school) carries to

a temporary conclusion the idea of using several view-points in representing the objects he portrays. (In the text of this book I offer a description of the method by which the masters called the Primitives rendered separate moments of time simultaneously.)

25. PABLO PICASSO (1881–). Figure.

The order followed in presenting the illustrations just before and after this one is that of the evolution of the new pictorial ideas, and not that of the chronological place of the various artists who aided in their development. Picasso, for example, stands at the very beginning of the Cubistic development. I have preferred to represent him by this important picture (of the year 1912), in which the relations of forms and spaces are rendered with almost complete independence from physical appearances. Some of Picasso's most admirable production is in the style of this work.

26. JACQUES VILLON (1874–). Study for a Portrait.

A picture similar in conception to the Picasso just preceding, but showing the different temperament of the French painter, with his more clearly ordered construction. The Cubistic formula permitted the various personalities to appear quite as freely as did the naturalistic conventions.

27. MARCEL DUCHAMP (1887–). The King and the Queen Surrounded by Swift Nudes.

The earlier work of Duchamp had transposed elements taken from the visible world, as the painters previously mentioned had done. In the more personal expression which continued the evolution of Duchamp's art, the forms and colors approach always more closely to absolute invention, as compared with imitative or even adapted form. An example of this stage in his work is the picture here reproduced. The title must be construed figuratively—

the words King and Queen evoking the idea of dynasty, of the permanent things of the world; the nudes standing for the naked, nameless crowd—the things that pass. Duchamp has preferred to let his painting be its own explanation, and for the many who have felt its great power, no added words are necessary. The desire to fathom the exact meaning of the title which he has painted at the bottom of the canvas is, however, a natural one. I therefore offer, though with some reluctance, the interpretation suggested above; it would make the opposition of forms in the painting a contrast between the forces of stability and instability. Doubtless, the future will no more ask for explanations of the modern works than we ask a translation into words of the beauty of a Rembrandt portrait or a Greek marble.

28. RAYMOND DUCHAMP-VILLON (1876–1918).
 Baudelaire (Bronze).

The work mentioned in the text. Persons who knew Baudelaire have said that this sculpture is one of the best portraits of the poet; the artist knew him only through the writings, which he admired profoundly, and through photographs. The sculpture, one of the last works of Duchamp-Villon's earlier period, shows a marked accentuation of the planes. A year or two later, when evolving the bas-reliefs of his architectural decorations, he used forms derived from the planes of his previous works, and on returning to sculpture in the round, was able to give to it the deeply reasoned, while still deeply felt construction apparent in his last important work, the Horse.

29. DUCHAMP-VILLON. The Horse. (Bronze, the
 sculptor intended to make a definitive casting
 of the work in steel.)

The movement of the animal was studied by the artist in scores of drawings and in small sculptural models, many of which were made during the war, when, as an officer in

a cavalry regiment, he became an expert horseman. The sculpture, on which he had been at work for about a year before the war, was finished during visits to his studio while on leave. The work began, as all of Duchamp-Villon's later productions did, with naturalistic studies, the planes and directions of line and mass which seemed essential to the idea and the design gradually taking precedence over the details which partook more of the accidental. Simultaneously the work became an expression of Duchamp-Villon's idea that the world of to-day translates its thought in terms of the machine, which, with its power and speed, the dominant interests of the period, penetrates our whole conception of life. The "Theseus Slaying the Centaur" of Barye may certainly be taken as symbolic of the mood of his Romantic period; its portrayal of the conflict between a higher and a lower form of life—indeed the whole epic formed by Barye's work—is an expression of the energy released by the Revolution and triumphing under Napoleon. In parallel manner, Duchamp-Villon has resumed in the monumental sculpture here reproduced, the forces which molded the character of thought in his epoch. The older work and that of the contemporary artist are comparable also in the completeness with which their idea is assimilated into sculptural form. To appreciate this quality in a Barye is to safeguard oneself against error in the case of animal sculpture having a merely zoological interest; to appreciate the quality in Duchamp-Villon is to avoid confusion in the matter of those contemporary attempts to express the spirit of our period by merely copying the objects or scenes which typify modern conditions. It is the quality of art in the Duchamp-Villon as in the Barye which tells of the genuineness of their intellectual background, and which mark them as continuers of the tradition of great sculpture in France.

30. CONSTANTIN BRANCUSI. Mademoiselle Pogany.

Instead of the almost geometrical relationship among

the angles and planes apparent in the sculpture and painting of the French artists, the work of Brancusi employs curved surfaces controlled by a subtle instinct, in which one may see an Oriental strain. But the style of the "Mademoiselle Pogany" evolved from the earlier form in Brancusi's art (that of the years when he was among the best students of Rodin), and it did so with the same logic as that which carried the other modern men from naturalism to stylization.

31. HENRI ROUSSEAU (1844–1910). The Jungle.

A memory of the Mexican forests which Rousseau had seen some forty years earlier, when a soldier under the Emperor Maximilian. The minute fidelity to each detail of the scene helps in carrying the design of the picture through every inch of the large canvas; for this artist it also contributes to the rendering of deep aspects of character in the portraits.

32. DIEGO M. RIVERA. Fresco in the Ministry of Education, Mexico City.

The first of Rivera's great decorations was an allegorical work recalling the mural painting of the Renaissance masters. It was based on a severely geometrical scheme for which the lines of the building furnished the elements. His paintings of the following year (1923), of which one is here reproduced, are more spontaneous in conception— perhaps as a result of their derivation from rapid sketches from nature, but the artist's assimilating of the facts of observation into æsthetic form is none the less evident.

33. BRAQUE. Figure.

In each of the men who have passed through Cubism to a new style one notices that the essential character of the artist is the same at all periods. The fineness of the early Braque appears again in the fastidious choice of form and of tone in his Cubistic pictures. The work toward which

he is tending to-day has the same qualities of delicacy, of strength and of clarity. But the painter's method has completely changed: where, in his Post Impressionist period, he would have laid in the whole of a scene with approximately equal emphasis throughout, his years of working with the separate elements of a subject permit him to make his decisions as to the build of the picture with greater deliberation and sureness.

34. PICASSO. Fountain, Fontainebleau.

Some of the late Picassos seem to betray a conscious purpose to achieve monumental quality, as if the artist felt he needed it as a foil to the brilliancy of the line-drawing which he has continued to practice throughout his career. Perhaps the best of his works are those, like the present one, where the more severe and the more gracious aspects of his art meet and balance each other.

35. DERAIN. Still Life.

As Derain had initiated tendencies in the earlier developments of the artists of his generation, so his obtaining with naturalistic forms a structure parallel with that of the Cubists showed many men the possibility of pursuing æsthetic research with the elements furnished by representation. In the three years since this "Still Life" was painted, Derain has advanced again to even closer observation of appearances and to an even firmer control of the design which assures their unity.

36. MATISSE. Lithograph (1923).

The opulence of Matisse's art has never appeared so clearly as in his production of the last few years. His severe testing of each element that went into his picture gave to his earlier painting an aspect of research—which troubles some observers, while causing others to see in his later work a too facile profiting by the resources he had previously accumulated. I believe that a further acquaintance with his art will show that both these estimates

are wrong. The great sense of beauty which is Matisse's lent to the most rigorous of the simplifications he made in other years a quality more noble than that of merely intellectual investigation; and the purity as art of the form and color he then achieved, having remained as an integral part of his vision, he can to-day go on to work of the naturalistic type here illustrated and, through it, offer us a picture at once more profound and more subtle than those of former years. I present last this maturest accomplishment of one of the older modern artists because it seems to me the best proof that a period which, after the war and the peace, can still bring forth such work, will continue in the great tradition.

BIBLIOGRAPHY

The principal books on the masters of the earlier part of the modern period are accessible in every well selected public library, and need not be listed again here. Much of the literature on the later men is still in the form of uncollected articles in such magazines as Le Mercure de France, L'Occident, Les Cahiers d'Aujourd'hui, Les Soirées de Paris, L'Amour de l'Art, L'Esprit Nouveau, La Grande Revue; The Burlington, The Fortnightly Review; Kunst and Künstler, Jahrbuch der Jungen Kunst, Der Querschnitt, Die Kunst, Der Sturm; Valori Plastici; The Freeman, The International Studio, The Dial, etc., etc.

The following list of books makes no attempt at exhaustiveness, but merely offers to the reader a selection among the more important publications on leading figures and tendencies of the later time. I place first a few general works.

Duret, Théodore, *Manet and the French Impressionists.* J. B. Lippincott Co., Philadelphia, 1910.

Meier-Graefe, J.; *Modern Art,* 2 vols. G. P. Putnam's Sons, New York, 1908.

Faure, Elie, *Modern Art.* Harper and Brothers, New York, 1924.

Moore, George, *Modern Painting.* Charles Scribner's Sons, New York, 1892.

Bell, Clive, *Art.* Frederick A. Stokes Company, New York, 1913.

Bell, Clive, *Since Cézanne.* Harcourt Brace & Company, New York, 1922.

Fry, Roger E., *Vision and Design.* Brentano's, New York, 1921.

Vollard, Ambroise, *Renoir.* Vollard, Paris, 1919.

Bernard, Emile, *Souvenirs sur Paul Cézanne* and *Lettres de Paul Cézanne.* Mercure de France, two numbers, Oct. 1 and Oct. 16, 1907 (an indispensable document).

Vollard, Ambroise, *Cézanne.* Vollard, Paris, 1915.

Meier-Graefe, J., *Cézanne und Sein Kreis.* Piper, Munich.

Faure, Elie, *Cézanne.* Crès et Cie, Paris, 1923.

Redon, Odilon, *A Soi-Même.* H. Floury, Paris, 1922.

Mellerio, André, *Odilon Redon.* H. Floury, Paris, 1923.

Gauguin, Paul, *Noa-Noa.* Brown, New York.

Morice, Charles, *Gauguin.* Floury, Paris, 1919.

Fletcher, John Gould, *Gauguin.* Brown, New York.

Van Gogh, Vincent, *Letters of a Post-Impressionist.* Constable & Co., London, 1912. (Extracts from complete collections in Dutch and German—the latter in two volumes published by Paul Cassirer, Berlin, 1914).

Duret, Théodore, *Van Gogh.* Bernheim Jeune, Paris, 1916.

Meier-Graefe, J., *Vincent.* Medici Society, Boston, 1923.

Cousturier, Lucie, *Seurat.* Georges Crès & Cie, Paris, 1921.

Pach, Walter, *Georges Seurat.* Duffield & Co., New York, 1923.

Signac, Paul, *D'Eugène Delacroix au Néo-Impressionnisme.* Editions de la Revue Blanche, Paris, 1899.

Puy, Michel, *Rouault.* Editions de la Nouvelle Revue Française, Paris, 1921.

Faure, Romains, Vildrac, Werth, *Henri Matisse.* Georges Crès & Cie, Paris, 1920.

Matisse, Henri, *Propos d'un Peintre.* Article in La Grande Revue, Paris, Dec. 25, 1908.

Faure, Elie, *Derain.* Georges Crès & Cie, Paris, 1923.

Henry, Daniel, *Derain.* Klinkhardt & Biermann, Leipzig, 1920.

Bissière, *Georges Braque.* Editions de L'Effort Moderne, Paris.

Raynal, Maurice, *Braque*. Editions de Valori Plastici, Rome, 1921.

Raynal, Maurice, *Picasso*. Georges Crès & Cie, Paris, 1922.

Gleizes and Metzinger, *Cubism*. T. Fisher Unwin, London, 1913.

Apollinaire, Guillaume, *Les Peintres Cubistes*. Figuière, Paris, 1913.

Gleizes, Albert, *Du Cubisme et des Moyens de le Comprendre*. Editions de la Cible, Paris, 1920.

Henry, Daniel, *Der Weg zum Kubismus*. Delphin Verlag, Munich, 1920.

Uhde, Wilhelm, *Henri Rousseau*. Kaemmerer, Dresden.

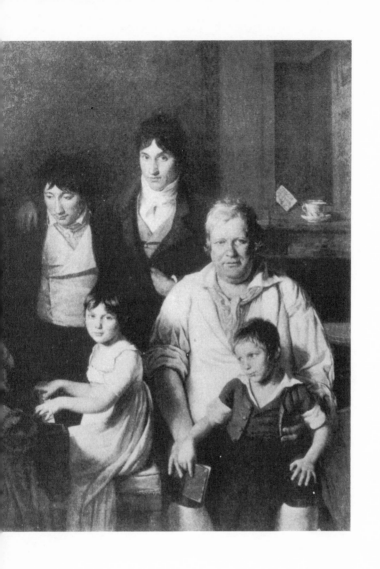

1. DAVID: *The Family of Michel Gérard*

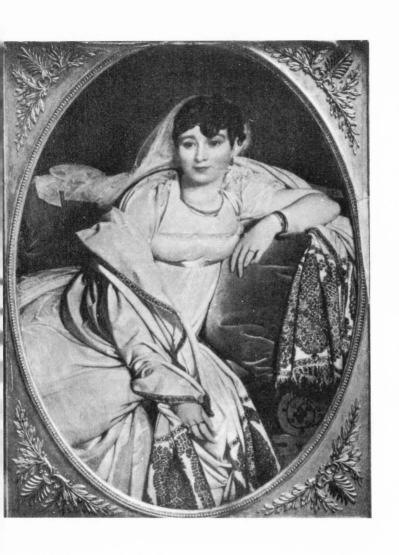

2. INGRES: *Madame Rivière*

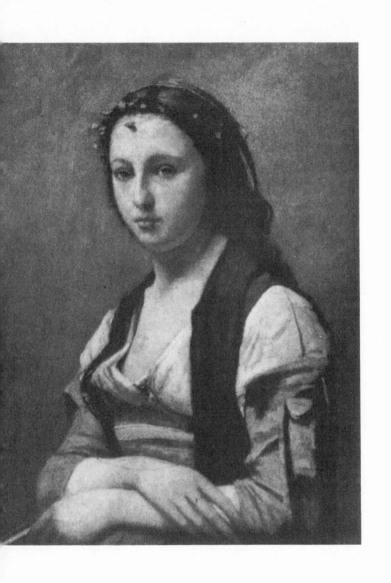

3. COROT: *The Woman with the Pearl*

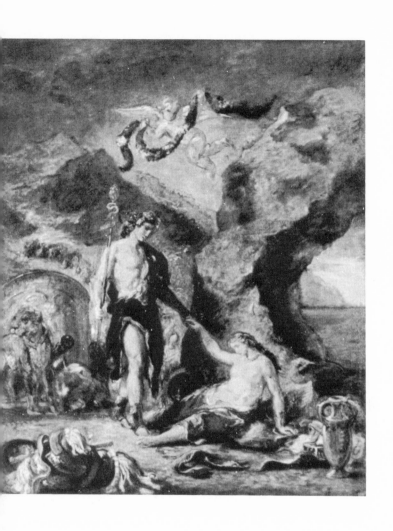

4. DELACROIX: *Bacchus and Ariadne (The Spring)*

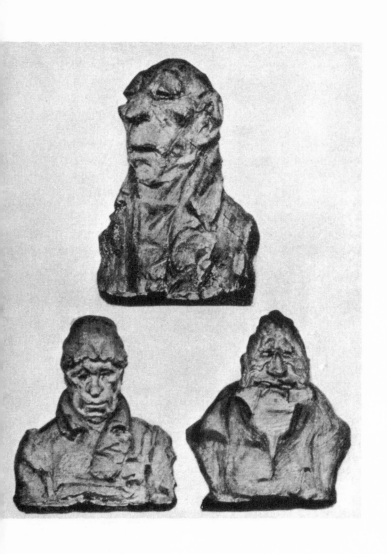

5. DAUMIER: *Small Sculptural Models of Heads*

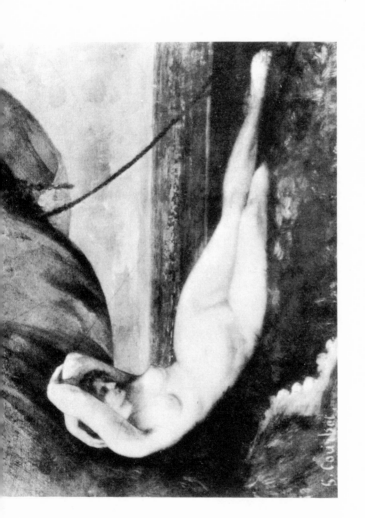

6. COURBET: *Woman on a Ship*

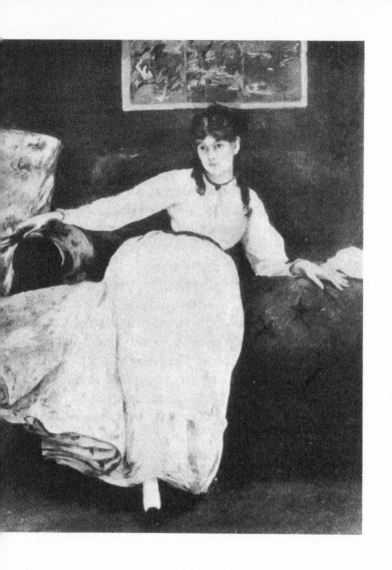

7. MANET: *Berthe Morisot (Le Repos)*

8. MONET: *Landscape in Norway*

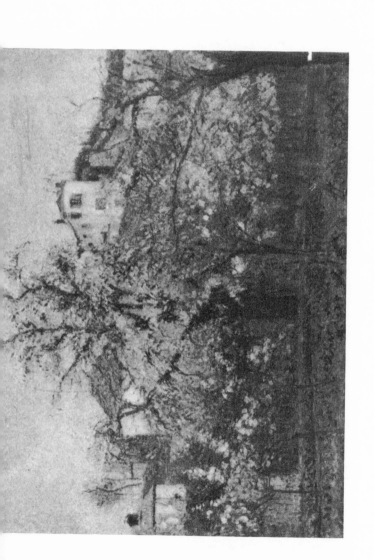

9. PISSARRO: *Garden with Flowering Trees*

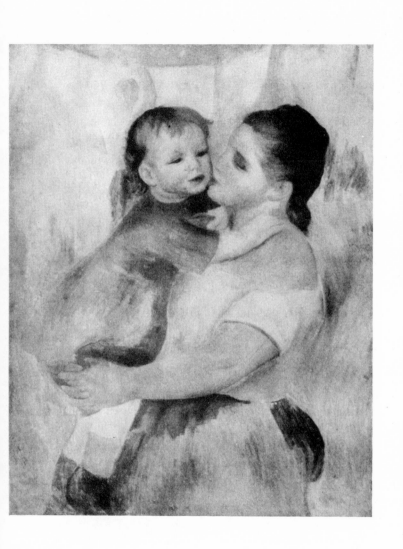

10. RENOIR: *Mother and Child*

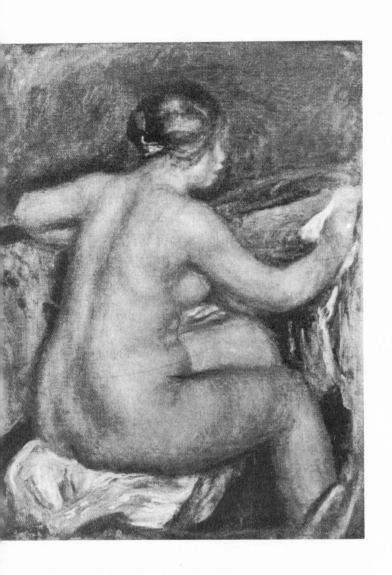

11. RENOIR: *Nude*

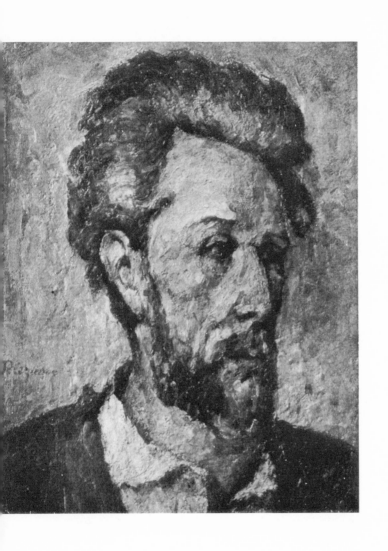

12. CÉZANNE: *Portrait of M. Chocquet*

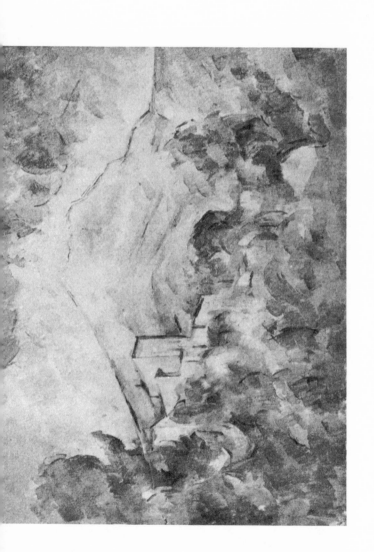

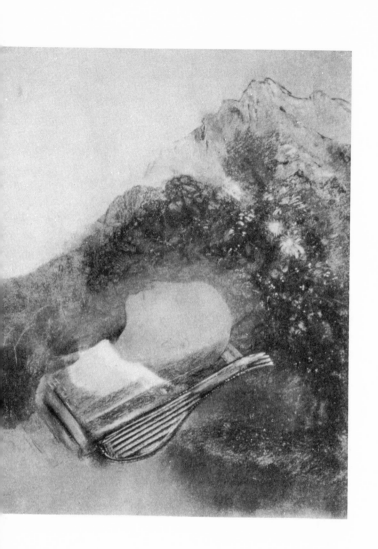

14. REDON: *Orpheus*

15. GAUGUIN: *Tahitian Pastorals*

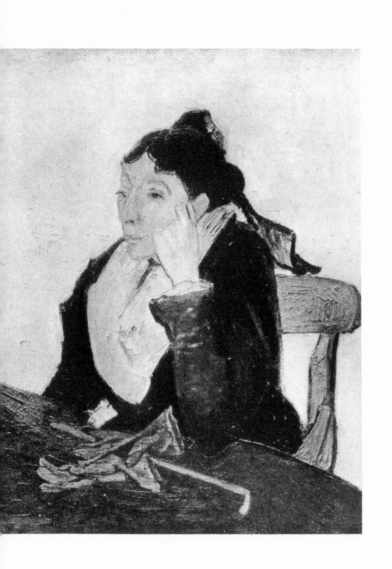

16. VAN GOGH: *Madame Ginoux (L'Arlésienne)*

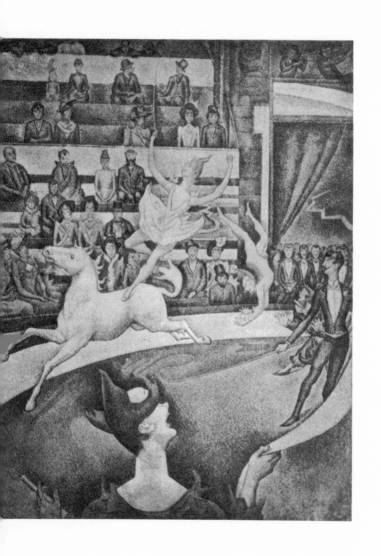

17. SEURAT: *The Circus*

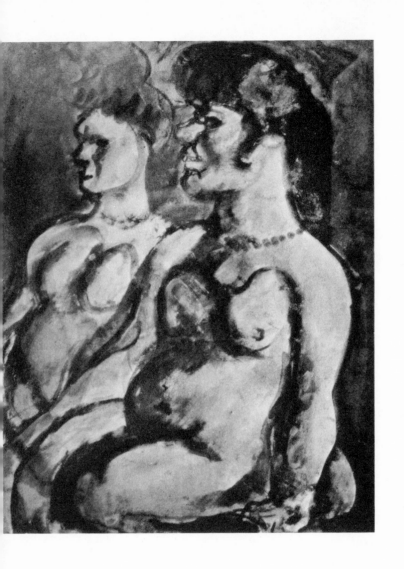

18. ROUAULT: *Two Women*

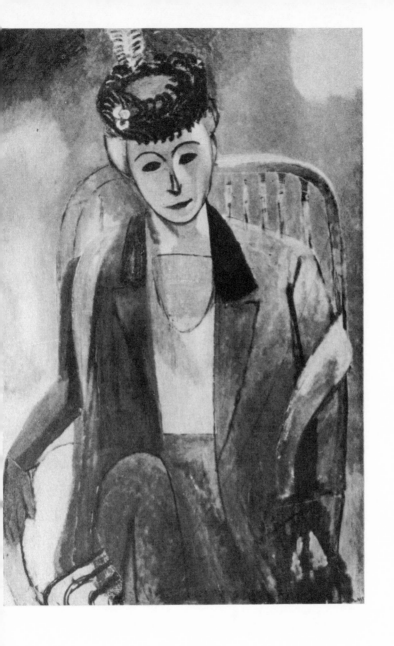

19. MATISSE: *Portrait of Mme. Matisse*

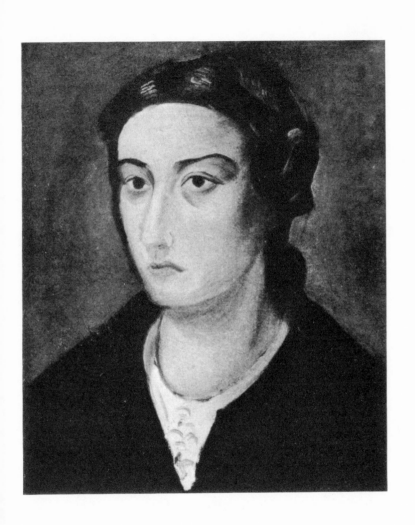

20. DERAIN: *Portrait of Mme. Derain*

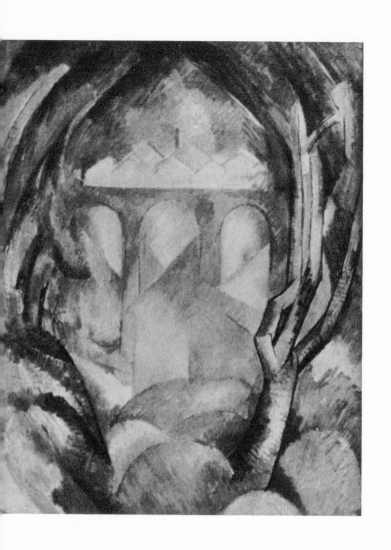

21. BRAQUE: *The Viaduct of Aix-en-Provence*

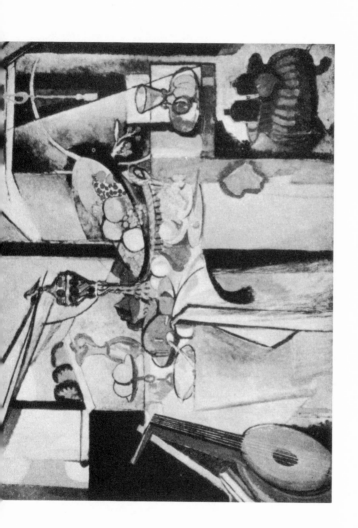

23. GLEIZES: *Landscape*

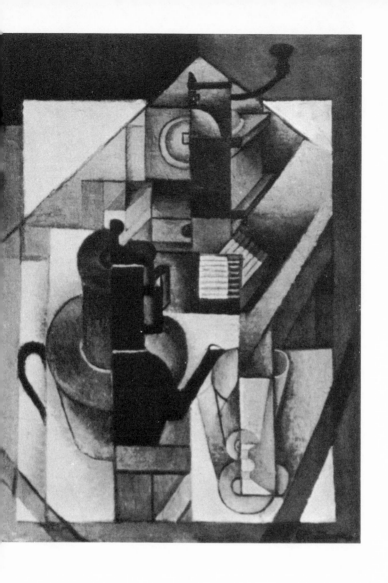

24. METZINGER: *Still-Life*

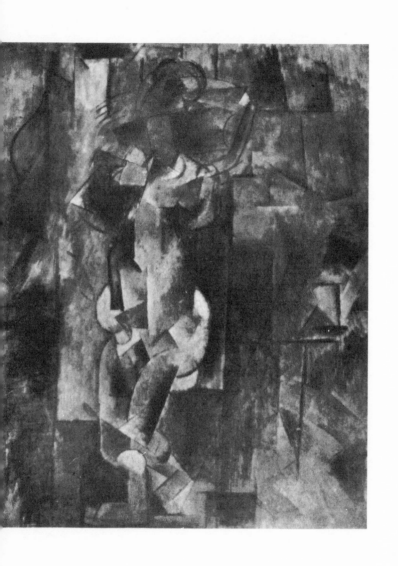

25. PICASSO: *Figure*

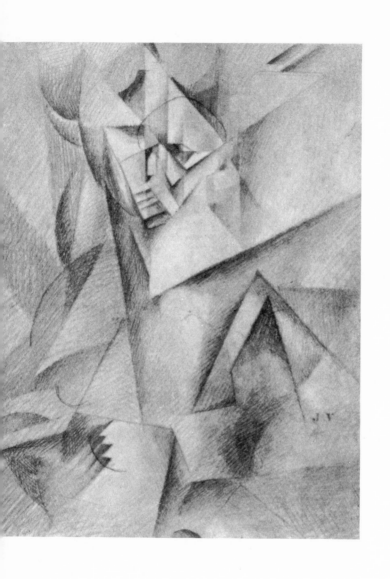

26. VILLON: *Study for a Portrait*

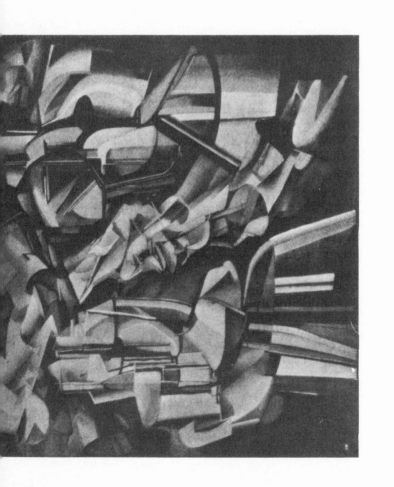

27. DUCHAMP: *The King and Queen Surrounded by Swift Nudes*

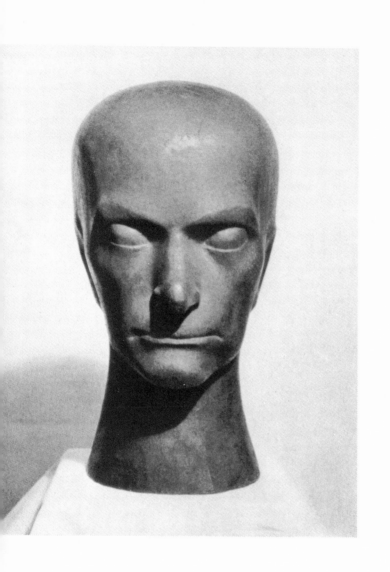

28. DUCHAMP-VILLON: *Baudelaire*

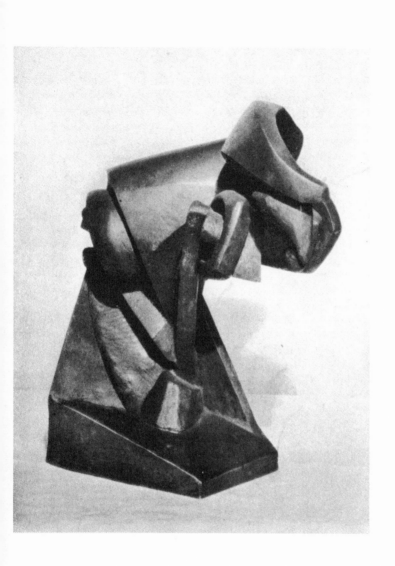

29. DUCHAMP-VILLON: *The Horse*

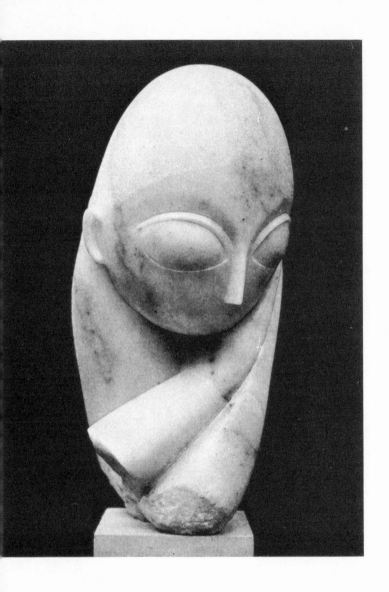

30. BRANCUSI: *Mademoiselle Pogany*

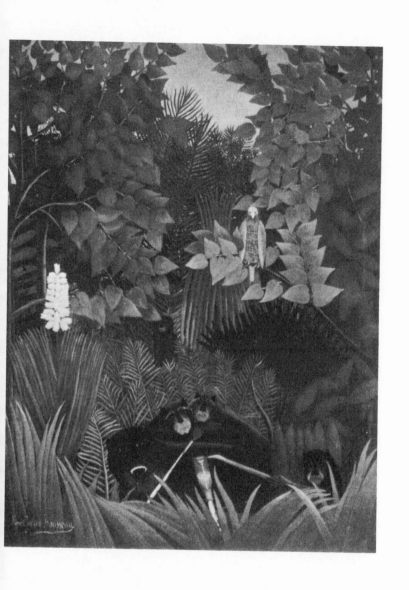

31.　HENRI ROUSSEAU:　*The Jungle*

32. RIVERA: *Fresco*

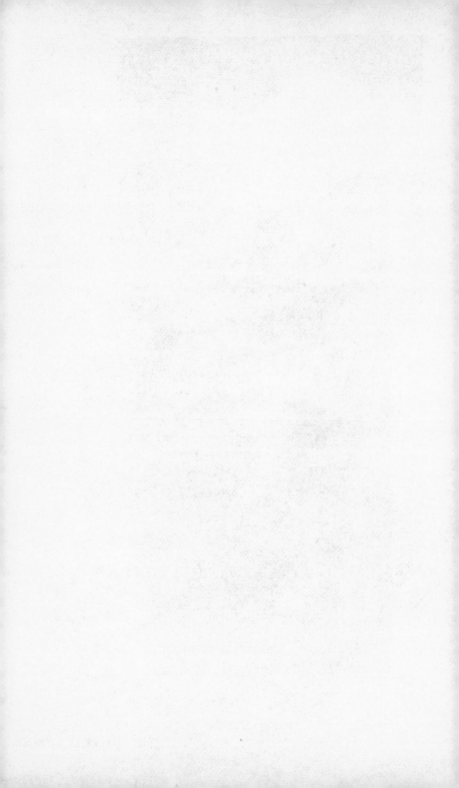

33. BRAQUE: *Figure*

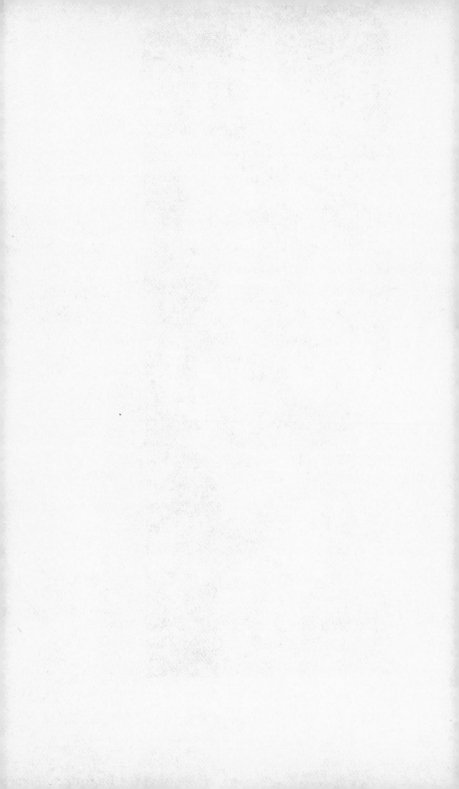

34. PICASSO: *Fountain, Fontainebleau*